THEN & NOW

CENTRAL PARK

Opposite: A young lady and a younger gentleman pass a quiet afternoon on the lake around 1880. (Author's collection.)

THEN & NOW

CENTRAL PARK

Edward J. Levine

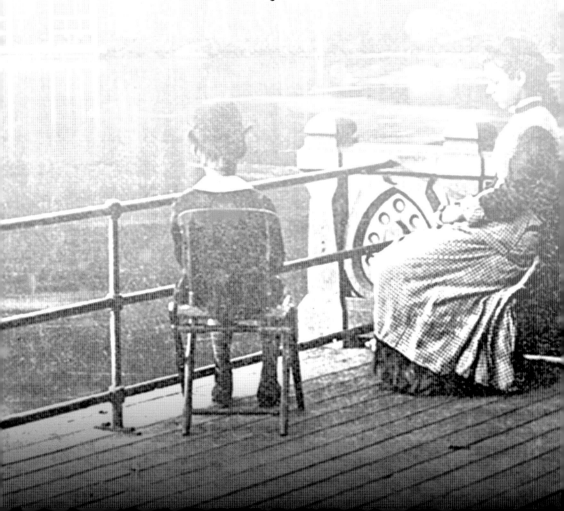

For Denise, the love of my life.

Library of Congress control number: 2007929106

Published by Arcadia Publishing
Charleston SC, Chicago IL, Portsmouth NH, San Francisco CA

Printed in the United States of America

For all general information contact Arcadia Publishing at:
Telephone 843-853-2070
Fax 843-853-0044
E-mail sales@arcadiapublishing.com
For customer service and orders:
Toll-Free 1-888-313-2665

Visit us on the Internet at www.arcadiapublishing.com

On the front cover: Visitors are often surprised to learn that the Sheep Meadow was once home to a flock of Southdown sheep. The Southdowns did, in fact, graze there from the park's early days until 1934, when they were removed to Brooklyn's Prospect Park. Today the Sheep Meadow, framed by its breathtaking skyline view, is among the park's most popular locations for sunbathing and relaxation. (Historic image, author's collection; contemporary image courtesy of Denise Stavis Levine.)

On the back cover: Journalist Arthur Wakeley, describing Bethesda Terrace and Angel of the Waters fountain in the September 1895 issue of *Munsey* magazine, wrote, "Two broad flights of steps of yellow tinted stone descend to the Esplanade at the edge of the Lake . . . Looking down across the Esplanade, the view is one of quiet and peaceful beauty." Thousands of daily visitors shared Wakeley's sentiments in 1895 and continue to do so today. (Author's collection.)

CONTENTS

Acknowledgments

Sincere thanks goes to some wonderful people without whom this book might never have seen the light of day, including Denise Stavis Levine, an outstanding photographer, exemplary teammate, and best friend; Dr. Naiyer Abbas Rizvi and his peerless team, whose excellence and support have been significant beyond description; and Roy Rosenzweig, who coauthored the seminal *The Park and the People*. I was saddened to learn in October 2007 of Roy Rosenzweig's untimely death. A researcher, historian, visionary, and all-around great guy, he will be sorely missed. Also Eve Rothenberg, who supports my research and always does so with a smile; Francine Stavis, peerless provider of love and soup; Roger Stavis, the rock of Gibraltar, who holds it all together; Bob Stonehill, who provided a wonderful vintage photograph of McGown's Tavern; and Erin L. Vosgien, editor extraordinaire.

INTRODUCTION

The poet William Cullen Bryant voiced what may have been the first public sentiment for the creation of a park in Manhattan. In 1844, during an era of rapid growth, Bryant wrote, "Commerce is devouring inch by inch the coast of the island, and if we would rescue any part of it for health and recreation it must be done now . . . [the island's] rocky and uneven surfaces [could be made] into surpassing and beautiful pleasure-grounds."

Over the next few years, landscape architect Andrew Jackson Downing, who wrote in the *Horticulturist* from 1849 to 1851, expanded on Bryant's thinking, "A large public park would not only *pay* in money, but largely civilize and refine the national character, [and] foster the love of rural beauty . . . In such a park, the citizens would take excursions in carriages, or on horseback . . . and forget for a time the rattle of the pavement and the glare of brick walls." Downing perished in 1852 in a steamboat accident, but his voice had been heard, and momentum to build the park was growing.

In 1853, the New York State legislature authorized funds to purchase the land on which to build the park. The board of commissioners was created in 1857, and work began immediately to clear the land when the commissioners hired landscape architect and journalist Frederick Law Olmsted as the project superintendent. After an initial plan for the park was scrapped, Olmsted teamed up with the British-born architect Calvert Vaux and submitted a visionary proposal for the design competition.

Olmsted and Vaux's entry, known as the Greensward Plan, was the winner. A report to the state senate said of the Greensward Plan, "The plan is harmonious; it is an entire design for the whole ground, contrived with the knowledge of the capacities of the land, and of the wants of a great city." Construction began in earnest as rock was blasted and pipes were laid. The first tree was planted on October 17, 1858, and, as work continued, a portion of the park was opened to the public late that year. Much of the park as it is known today had been built by the mid-1860s and, by the early 1870s, the construction of Central Park had been completed. True to the early vision of Bryant and Downing, the park indeed provided a respite from the sights and sounds of the growing metropolis.

While the city grew up around Central Park, the park continued to prosper through the mid-20th century. For those New Yorkers and visitors who experienced the myriad pleasures of the park, the decline that began after World War II would have been unimaginable. Writing in 1966, Henry Hope Reed, the park's curator, declared, "The park's sad condition has been matched, unfortunately, by a total breakdown in public discipline. Poor maintenance has only encouraged a careless public attitude."

The park was in sorry condition, plagued by underfunding, crime, and public apathy, when the Central Park Conservancy began raising money for its restoration in 1980. Today through the efforts of the conservancy, a nonprofit organization working with the city of New York, most of the park has been restored to its original splendor, and 30 million visitors each year can enjoy its near-pristine condition.

The conservancy offers the following description of the role Central Park plays in 21st-century New York, "What every Park visitor does know is that Central Park is a

haven. It is a place where all of us can alter the frenetic rhythms that make New York the most exciting city in the world. We can sit on a bench and read the paper, toss a ball with friends, jog, cycle, or play with our children. Connections with Central Park run especially deep with New Yorkers. We tend to think of the Park as our own front yard."

In the effort to create a comprehensive then and now record of Central Park, which may be the most effective and enjoyable way of studying its history, the author and photographer encountered some interesting challenges. Some features, such as the Marble Arch and the casino, no longer exist. In these situations, the historical and contemporary images are totally different. We trust that the reader will take it on faith that this is the same place. Other features, while still extant, have changed markedly, such as the Huddlestone Arch or Balcony Bridge. In viewing these images, we suggest that the reader find an anchor in the historical photograph that helps to make the connection to the contemporary photograph. Finally, in a few cases, we were unable gain access to a certain area to provide a current image. For example, much of the Ramble is currently being restored. This challenge proved most formidable, and as a result, this portion of the park is underrepresented in this volume.

Researching this book has been a labor of love. Most of the historical photographs are from the author's collection of 19th-century stereoscope view cards. Contemporary images were taken by Denise Stavis Levine. There is no shortage of historical photographs depicting the park's early years, and we thoroughly enjoyed creating a contemporaneous catalog as a companion to this collection. We hope the accompanying captions help to provide a context for the park's evolution and add to your viewing pleasure.

Please visit the author's Web site, www.edlevine.net. We encourage your questions or comments via e-mail at ed@edlevine.net. Enjoy.

THE SOUTHERN END

CENTRAL PARK SOUTH TO

THE DAIRY

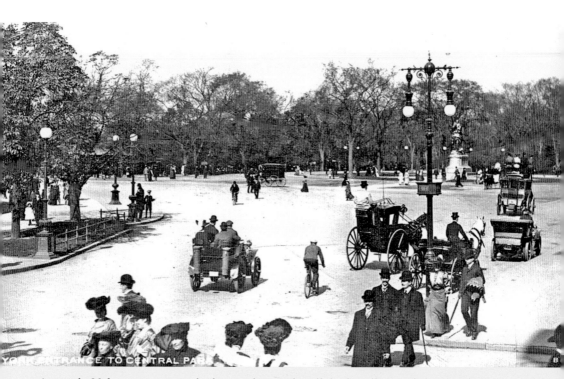

An early-20th-century view looks north from 58th Street toward the Sherman statue and Scholar's Gate, the park's Fifth Avenue entrance at 60th Street. Gentlemen of the day wore derbies and celluloid collars, while the ladies strolled in elaborate hats and elegant dresses. Transportation was by bicycle, carriage, or that newfangled invention, the automobile.

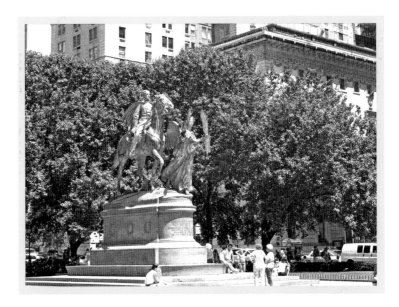

Sculptor Augustus St. Gaudens's masterwork, the statue of Civil War general William Tecumseh Sherman, has stood in Grand Army Plaza at Fifth Avenue and 60th Street since 1906. At right, the four stories of the Metropolitan Club, an 1893 design by Stanford White, are visible in the early photograph; today trees obscure all but the top level and the roofline.

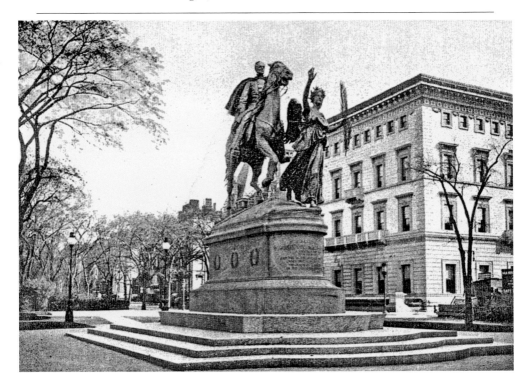

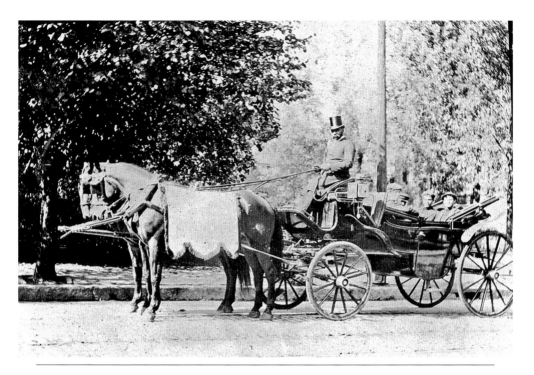

Horse-drawn carriages have been seen in and near Central Park since its earliest days. The winding park drives were designed for their use in an era well before automobiles became part of the urban landscape. Today visitors to the park can share the experience of their counterparts from the dawn of the 20th century in a restored vis-à-vis carriage.

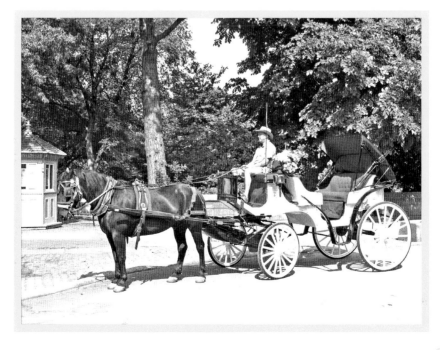

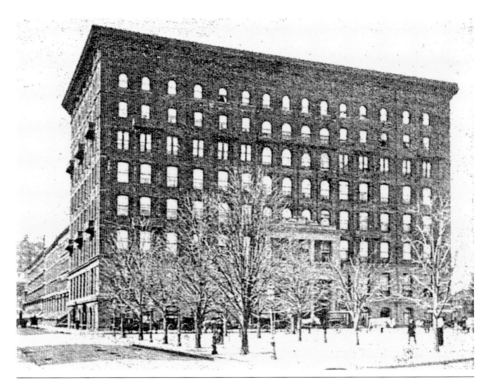

The eight-story redbrick building at Central Park South and Fifth Avenue was originally planned as an apartment house. After the developers went broke, the new landlords hired noted architects McKim, Mead, and White to transform the building into the first Plaza Hotel, which opened in 1890. However, it lasted only 12 years before it was demolished and replaced by what has become one of the world's most recognizable buildings, the current Plaza Hotel, which opened in 1909.

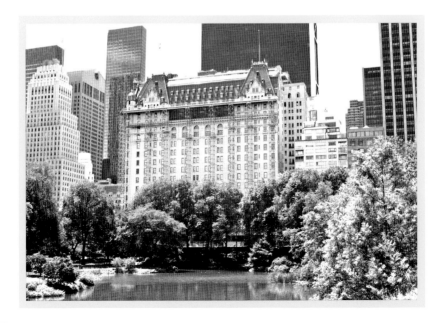

The Southern End: Central Park South to the Dairy

Ice-skating was among the most popular activities from the day the park was opened to the public. On cold winter days, it was not uncommon for 50,000 to 100,000 skaters to lace up skates and take a whirl. Nestled in a corner of the pond, just north of what is now the entrance to the N and R subway, stood a building known as the skating tent. There one could rent skates for a few cents and return after skating for a cup of hot chocolate or perhaps something stronger. The skating tent was demolished around 1940.

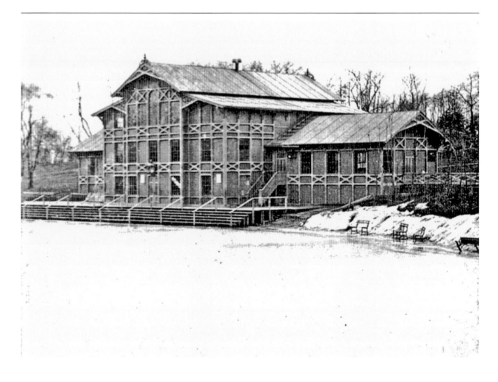

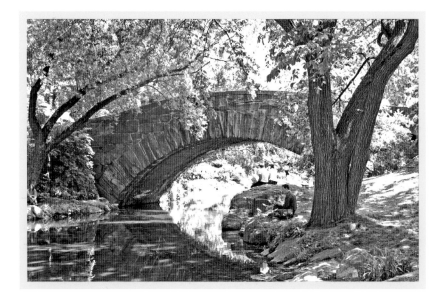

Ten years after the park opened, carriage and pedestrian traffic had become a major problem. The first Gapstow Bridge, spanning the pond just below where Wollman Rink stands today, was built to address that congestion. Featuring wood walkways and cast-iron railings, the old bridge soon wore out from overuse and, by 1895, was in danger of collapse. It was replaced the following year by the current stone structure comprised of the same Manhattan mica schist that is the park's bedrock.

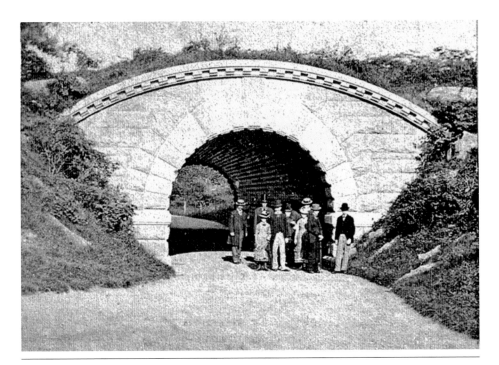

The 34-foot-long, Tuscan-style Inscope Arch, better known in the 19th century as Menagerie Arch, was the second of the three bridges built in response to the park's traffic problems; it is the only one of the three still standing. Designed by Calvert Vaux, Inscope Arch was built with great difficulty on pilings driven into quicksand. Standing just south of the zoo, the arch has been reappointed and cleaned, and its interior lighting has been repaired. Inscope is an element of the park that has changed very little over the years.

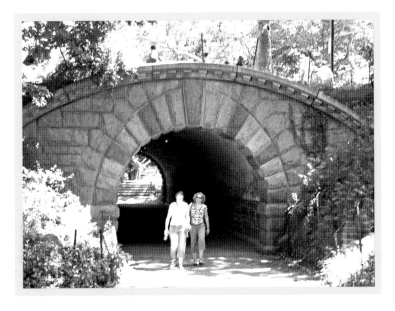

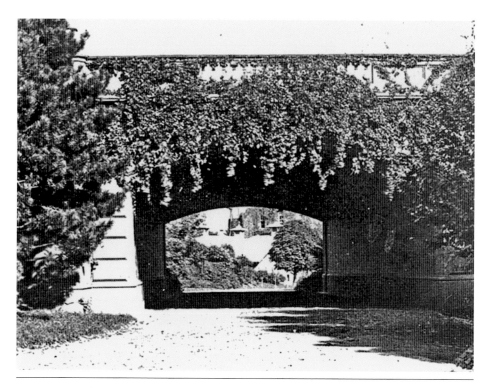

Greengap Arch, designed by Calvert Vaux and Jacob Wrey Mould, is one of the park's oldest structures. Standing 13 feet high and 25 feet wide, the arch was originally part of the bridle path's now-truncated lower loop, leading equestrians under the East Drive toward Scholar's Gate. Later it served as the western entrance to the zoo. Today it is closed to traffic, and its 81-foot-long underpass serves as a storage area.

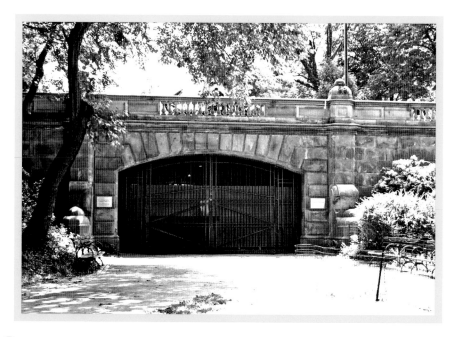

Outset Arch, the last of three bridges built in the 1870s to address the park's traffic problems, stood until the 1930s, when the old menagerie was expanded to create the current Central Park Zoo. Outset's magnificent railings and elaborate cast-iron ornamentation spanned the bridle path at what is now the zoo's southwestern corner. It is nearly unimaginable today, but under the prevailing values of the Depression era, Outset Arch was destroyed in the name of progress.

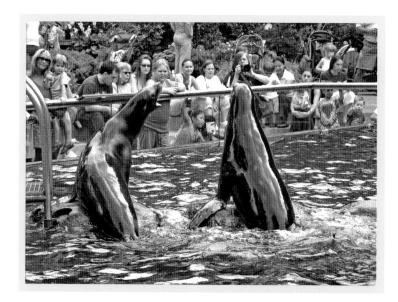

A September 1879 article in *Harper's Monthly* described the menagerie's seal pool as "a large inclosure with a tank in the centre [that] contains the seals." Today the updated and modernized seal pool continues to be one of the most popular attractions with the one million annual visitors to the Wildlife Conservation Society's showplace facility.

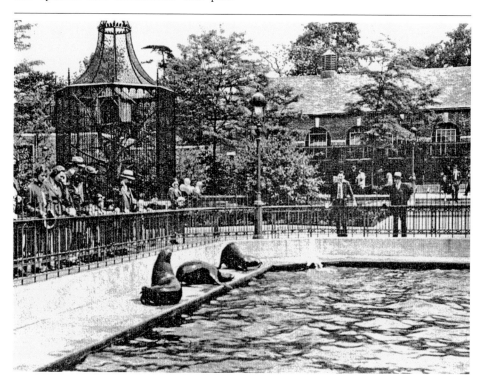

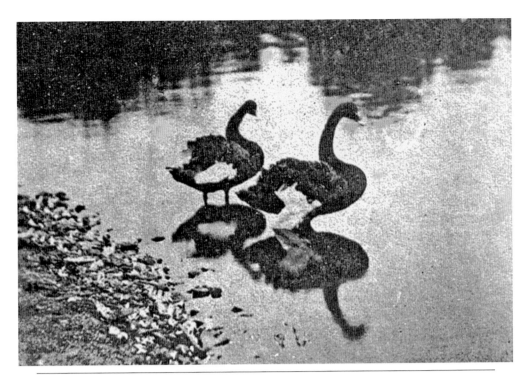

The 1879 *Harper's Monthly* article also describes the park's community of swans, "There are at present on the Lake thirty mute swans, six wild, three American trumpeters, and twelve black ones." The black swans were a gift to New Yorkers from the people of Australia. Swans are still very much in evidence in the park, both on the lake and in the zoo, although there is nary a black one in sight.

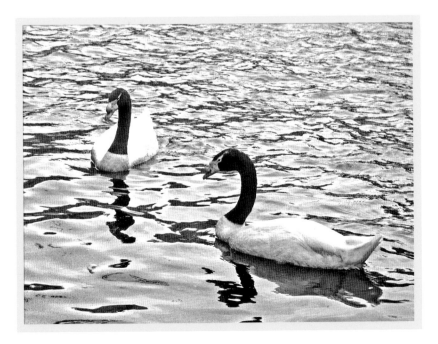

At one time, the eagle's cage was a major attraction of the menagerie. By modern standards, their captivity was a brutal one, as described in the September 1879 *Harper's Monthly*, "[The eagles] inspire pity, as they flutter heavily about their cage, screeching in discordant fashion, as if protesting against confinement in the very land where they are the symbol of liberty." Today cages have been replaced by netting, creating significantly more humane conditions than once prevailed.

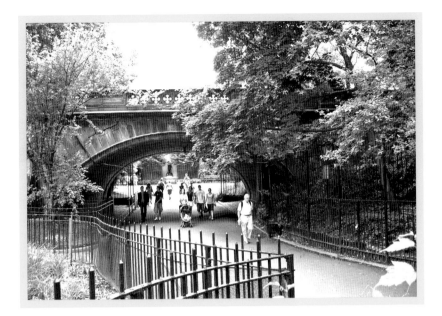

The 37-foot-wide, 14-foot-tall Denesmouth Arch at the northern end of the zoo was built in 1865, carrying the 65th Street Transverse Road toward its eastern exit at Fifth Avenue. The Gothic-style quatrefoils carved into its balustrade are clearly visible in the early photograph and may be seen peeking through the trees in the contemporary image. The young man posing with his boneshaker bicycle has been replaced by a baby carriage and pedestrian traffic in the modern view.

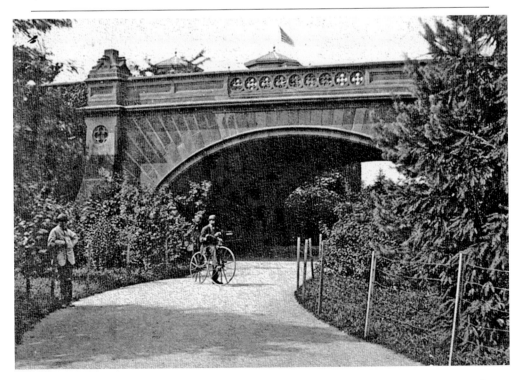

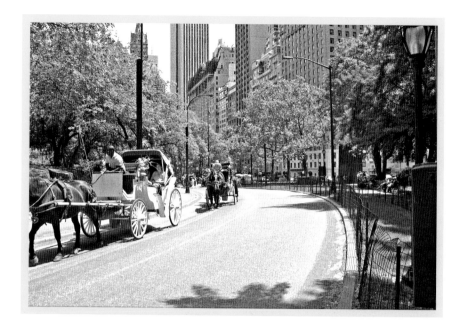

In Central Park's early years, carriages at the southern end could gain access to the park drives only through Scholar's Gate at Fifth Avenue and 60th Street or through Merchant's Gate at Columbus Circle. That changed early in the 20th century when the park drives were expanded and Artist's Gate at Sixth Avenue and 59th Street was opened to carriage and automobile traffic, creating this striking visual contrast.

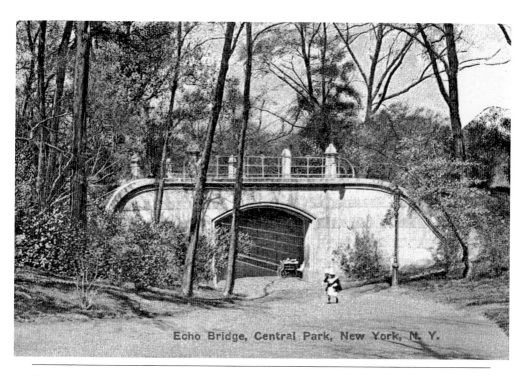

Echo Bridge, Central Park, New York, N. Y.

Dipway Arch, also known as Echo Bridge, carries the park drive in an east-west direction just south of Heckscher Playground. As designed by Calvert Vaux, Dipway features fanciful ornamentation, including striped courses of light and dark granite masonry on the external elevations, diagonal courses of multicolored brick inside the archway, and uncomplicated cast-iron railings on the overpass. At one time, benches lined the arch, providing a quiet and cool resting spot for weary pedestrians.

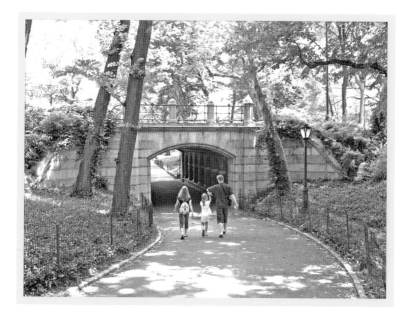

In the park's earliest days, Jules Fesquet's statue, titled *Commerce*, stood just above Merchant's Gate near the park's Columbus Circle entrance. Directly north of *Commerce*, the imposing 100-foot balustrade of Calvert Vaux's Greyshot Arch stood, visible at lower left of the historical photograph. While Greyshot Arch is still intact and heavily used by pedestrian and motor traffic, the questions of when *Commerce* was removed and where it might be today are among the park's enduring mysteries.

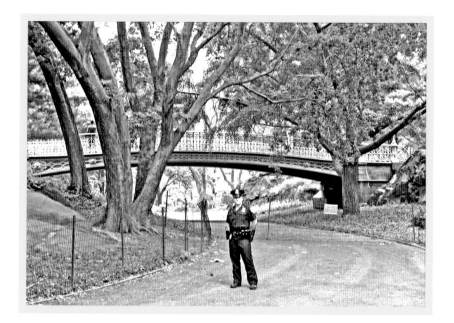

A New York State Senate report, issued on January 25, 1861, described the need for law enforcement in the park, "The preservation of order on the park is of the very first importance . . . and it is due to the city [to] ensure the proper control and government of this pleasure ground of the people, and to secure it from the incursions of the lawless and disorderly." New York's finest, seen in historical and contemporary views on the bridle path at Pinebank Arch, have been keeping order in the park for nearly 150 years.

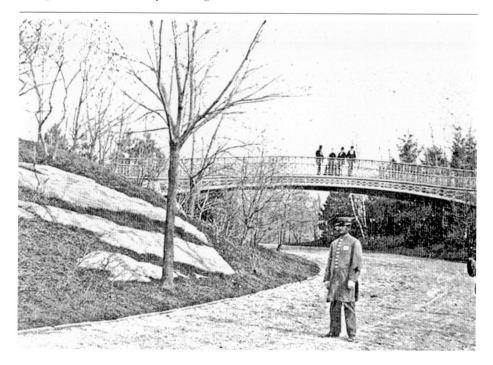

Spur Rock Arch once carried pedestrians over the bridle path's lower loop, north of Dipway Arch. As described by Henry Hope Reed, Robert M. McGee, and Esther Mipaas in their classic 1990 book, *Bridges of Central Park*, "Spur Rock was demolished because it got in the way of the expansion of the Heckscher Playground. Instead of being incorporated into the playground, Spur Rock, probably looking old-fashioned, rundown and unimportant in 1934, was destroyed. It was, in fact, irreplaceable." The lower bridle path is now a footpath, and no trace remains of Spur Rock Arch.

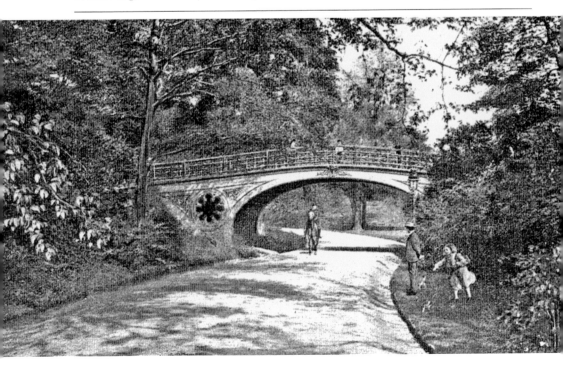

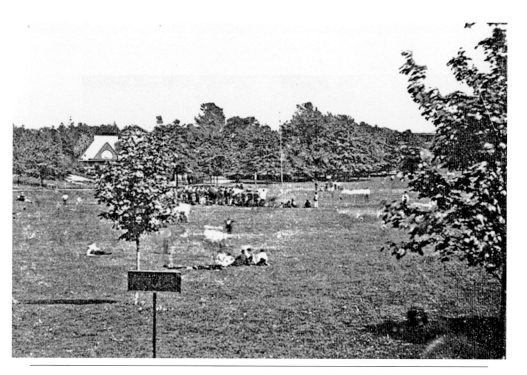

Described as "the cricket field" in early park literature, what is now the Heckscher Playground was an early site for baseball games. Located in the children's district of the park, the playground featured a Calvert Vaux–designed players' dressing room known as the ballplayers' house. Over the years, it fell into disrepair, suffered major damage from a fire after World War II, and was demolished in the 1960s. However, it was rebuilt to the exact original specifications in the early 1990s and serves today as a snack bar and refreshment stand.

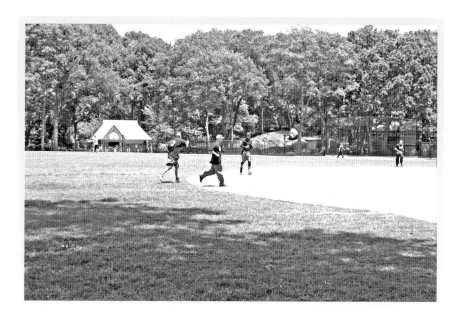

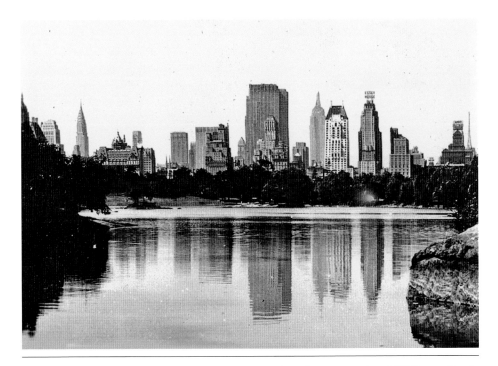

The pond at the park's southeastern corner, framed in the historical image by the city's pre–World War II skyline, originally reached as far north as the now-defunct lower loop of the bridle path. Today the pond ends just south of Wollman Rink, which was built on landfill. In the summer, Wollman Rink is home to a carnival, as seen in the contemporary photograph.

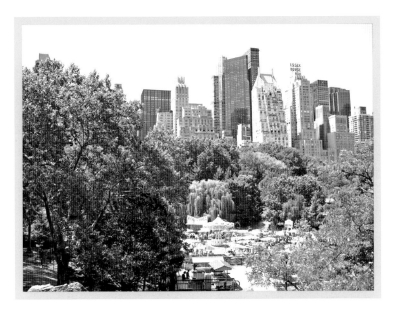

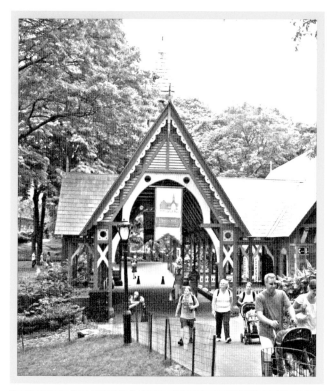

In 1870, the dairy was built just south of the 66th Street transverse. Designed by Calvert Vaux, the Gothic-style dairy was, according to Roy Rosenzweig and Elizabeth Blackmar's seminal 1992 work, *The Park and its People*, "conceived as a comfort station that would offer fresh milk to mothers and their children." Like many park buildings, it fell into disrepair over the years, losing its porch in the 1960s. Splendidly restored by the Central Park Conservancy, the dairy now serves as a visitors' center and the park's official gift store.

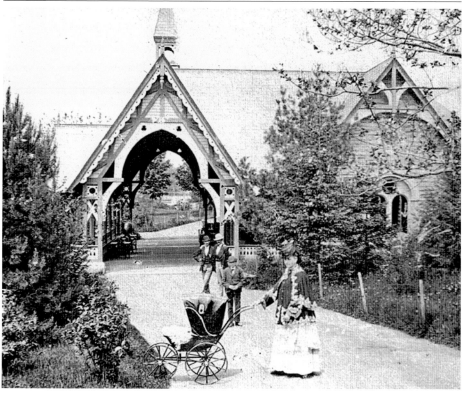

As magnificent as it may have been, the original park design included few facilities for children. According to Sara Cedar Miller in *Central Park, An American Masterpiece*, as a result of media criticism, the designers were instructed to create a "children's department in the lower park . . . [including] the Dairy and the Kinderberg, the largest rustic summerhouse in the Park." In 1952, the Chess and Checkers House, seen in the contemporary photograph, was built on the Kinderberg's original foundation.

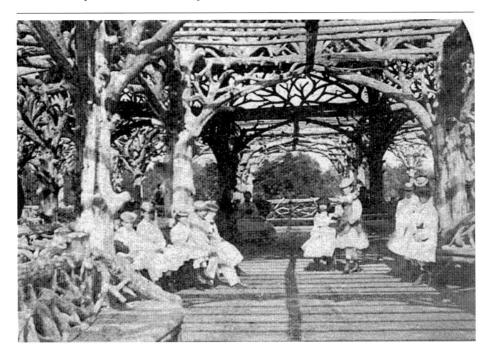

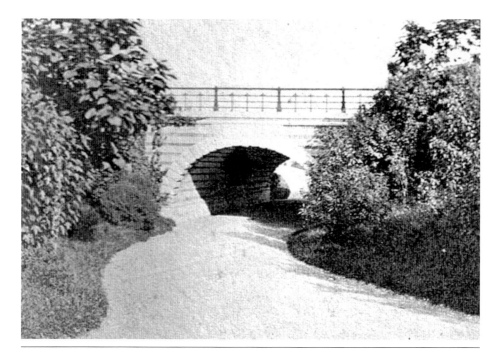

Playmates Arch, designed by Calvert Vaux and Jacob Wrey Mould, provides a pedestrian walkway between the dairy and the carousel, and serves as a bridge for the Center Drive. In *Bridges of Central Park*, Henry Hope Reed, Robert M. McGee, and Esther Mipaas describe Playmates Arch as "one of the most ornate masonry structures in Central Park with its characteristic Philadelphia pressed brick and Milwaukee yellow brick-belt coursing and granite trim." Its appearance has changed very little over the years.

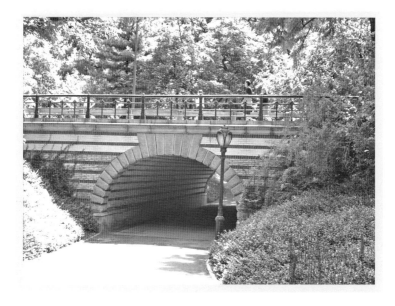

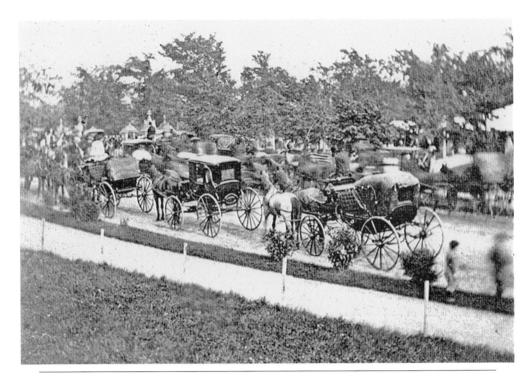

Even before construction was completed, New Yorkers eagerly anticipated the park's network of carriage roads, which were quickly filled to capacity. The historical image shows an early horse-drawn traffic jam in what resembles a free-for-all. Today there are fewer carriages, as illustrated in the contemporary photograph of the East Drive near the dairy.

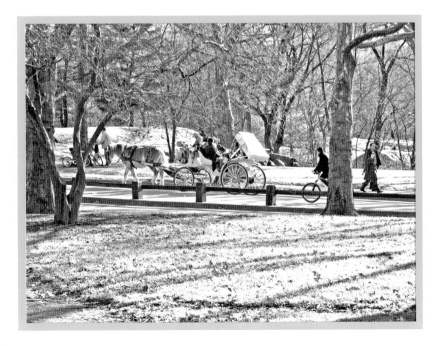

THE MALL
AND ENVIRONS

MARBLE ARCH TO TERRACE BRIDGE

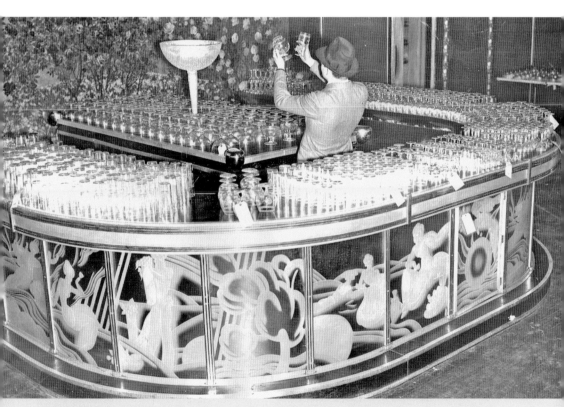

Dated March 14, 1936, this news photograph was captioned, "If you are interested in buying any number of glasses (glasses that have been quaffed from by prominent people), you might want to drop around to the Central Park Casino to look at this collection. It's part of the furnishings which will be auctioned Monday, March 16th." The spectacular art deco bar must have also caught bidders' fancy. For more on the casino, see pages 42 and 43.

Marble Arch, the park's only bridge made of marble, featured marble benches, a drinking fountain, and a semicircular pergola at one end, which can be seen in the historical photograph. Among the park structures that were destroyed in the tear-it-down atmosphere of the 1930s, Marble Arch was perhaps the greatest loss. In its day, it led to the now-defunct Center Drive, which is seen in the contemporary image.

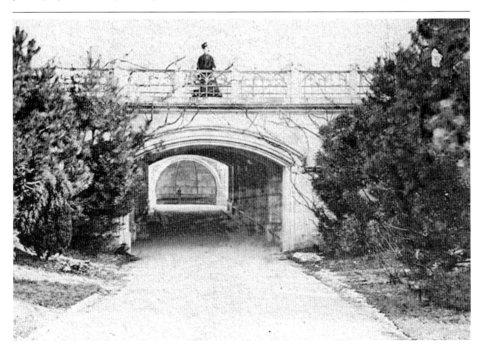

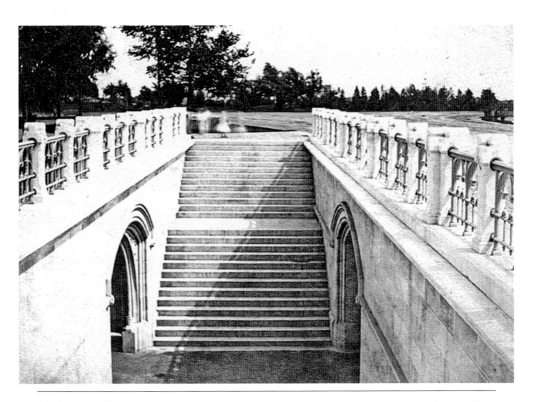

Marble Arch's grandest feature was a spectacular double staircase leading to the mall. When the park drives were realigned in 1938, the arch was demolished and broken into small pieces and buried in place. In recent years, a scarred chunk of marble has worked its way to the surface as if declaring, "Here Lies Marble Arch."

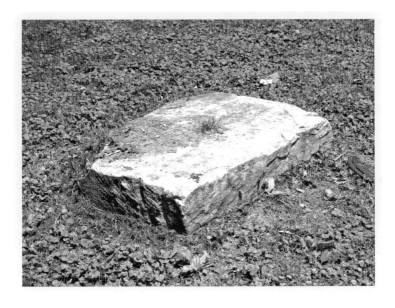

Sculptor John Quincy Adams's bronze statue of William Shakespeare was the first statue to be commissioned and built in the park. It was unveiled in May 1872 and featured a granite pedestal by Jacob Wrey Mould. Ever since the great Shakespearean actor Edwin Booth laid its cornerstone, Shakespeare has occupied a position of honor at the foot of Literary Walk.

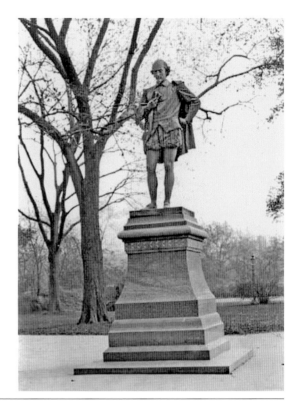

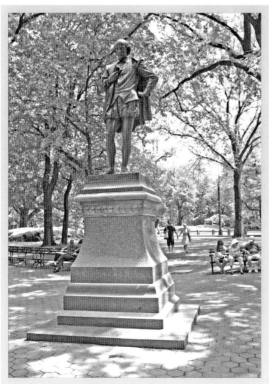

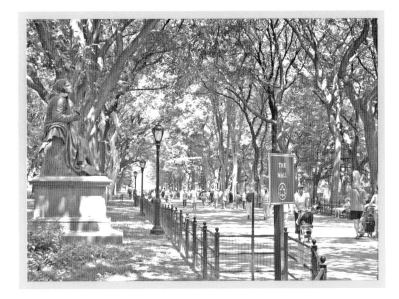

According to the Central Park Conservancy, the mall and Bethesda Terrace are the main formal elements in Frederick Law Olmsted and Calvert Vaux's design for Central Park. They acknowledged the public's need for a place to socialize; they knew that a grand promenade was an "essential feature of a metropolitan park." Also known as Literary Walk, the area features statues of Robert Burns (left), Fitz-Greene Halleck (in the distance, at center) and Sir Walter Scott (not visible in this photograph).

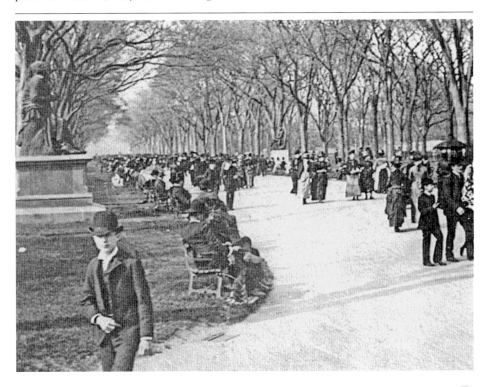

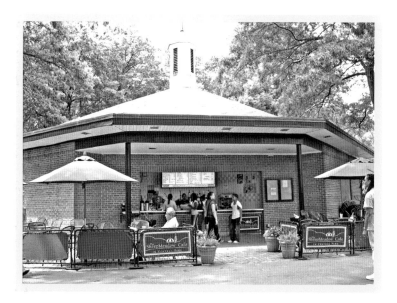

Nestled between the north end of Literary Walk and the West Drive, a wooden refreshment house called Mineral Springs Pavilion once stood, designed by Calvert Vaux and built in 1868. Its heyday was the 1890s, when, according to Henry Hope Reed and Sophia Duckworth's *Central Park: A History and a Guide*, "It was referred to in the press as 'Little Carlsbad' and offered a choice of thirty different types of mineral water." The Mineral Springs Pavilion stood until 1960, when it was torn down. Today the Sheep Meadow Café at Mineral Springs occupies the same location.

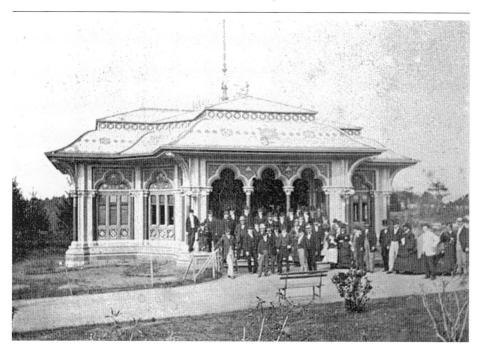

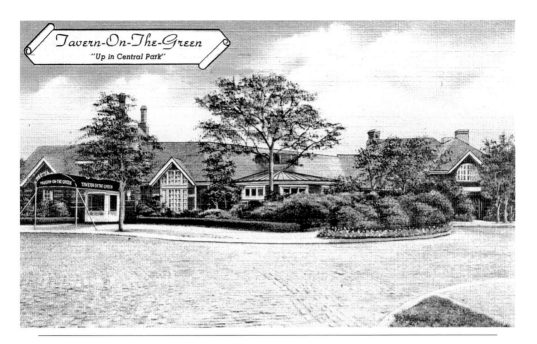

After the sheep were removed from the park, the Sheepfold, their former home, was transformed into the Tavern on the Green restaurant. Today the Victorian Gothic–style redbrick building designed by Jacob Wrey Mould is host to numerous weddings, receptions, and Broadway show galas and is among Manhattan's best-known restaurants. The Tavern serves more than half a million patrons a year in its six themed dining rooms, featuring antique prints, etched mirrors, Tiffany glass, and crystal chandeliers.

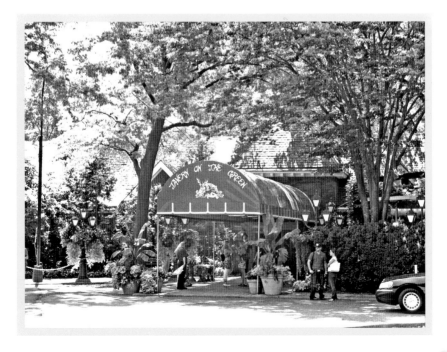

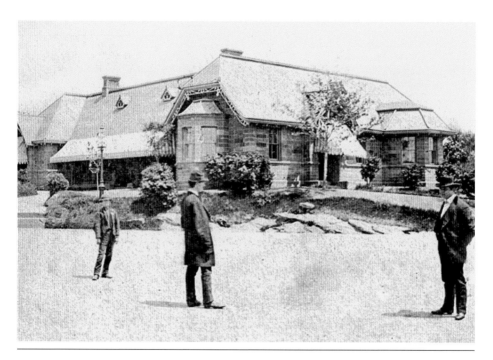

The Central Park Casino was located just northeast east of the mall on a site originally planned for a concert hall that was never built. The casino, which was designed by Calvert Vaux, began life modestly in the 1860s as the ladies refreshment pavilion. It was subsequently expanded, and by the 1920s, the casino had become one of Manhattan's swankiest entertainment venues. The carriage concourse behind the casino is now Rumsey Playfield, the home of Central Park's annual Summerstage, as seen in the contemporary photograph.

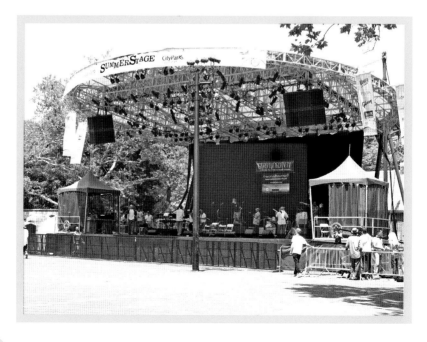

Featuring big band music, dancing, and fine dining, Manhattan's elite frequented the casino to see and be seen. Mayor Jimmy Walker became a regular, entertaining friends there nightly. Mayoral hopeful Fiorello LaGuardia made Walker's high living an issue in the 1929 mayoral campaign, and when LaGuardia beat Walker, the casino's days were numbered. It was demolished in 1935, and a utilitarian maintenance building currently occupies its former site.

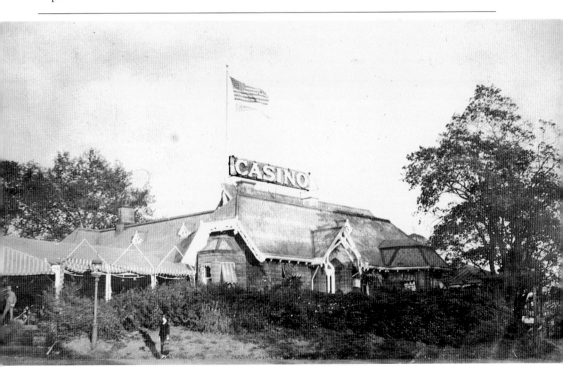

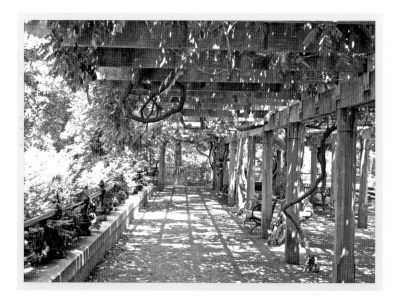

The Wisteria Pergola stands west of Rumsey Playfield, on a hill above the mall. In September 1879, *Harper's Monthly* described it as "a broad *alameda*, covered with blossoming creepers, reached by a narrow ascending path, where one may sit and watch the crowd of carriages circling around the Concourse, or overlook the Mall, the Music Pavilion, and the broad green lawn beyond." The vines have grown denser, but Wisteria Pergola remains nearly unchanged today.

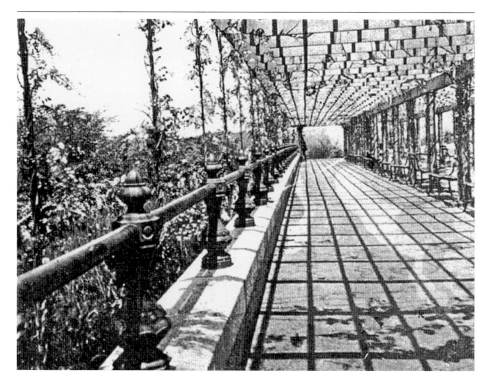

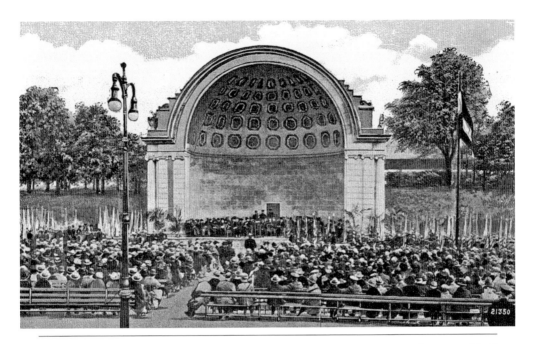

The Naumburg Bandshell, located at the northern end of the mall, was erected in 1923. As described by www.naumburgconcerts.org, "The use of European park architecture as a model for what to insert in Central Park was in keeping with Olmsted's design of nearly 60 years earlier. The Naumburg Bandshell was set into the Manhattan schist hillside, which nestles it, to prevent views from being blocked across the Mall and Concert Ground. [It is] Central Park's only Neo-Classical building." Today the site is popular among Rollerbladers.

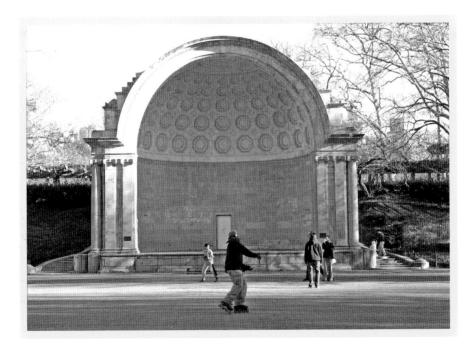

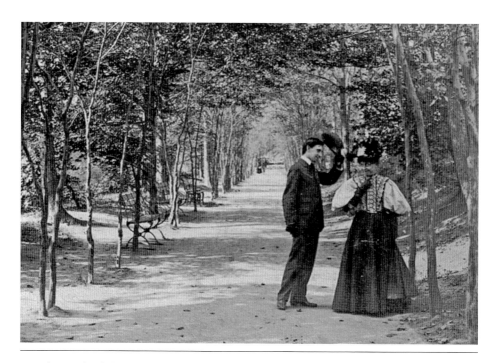

Just down the hill from Wisteria Pergola once stood a long, narrow, tree-lined path where Victorian couples were free to court. As described by Walter Karp in the March-April 1981 issue of *American Heritage* magazine, Central Park was "one of the few public places in New York where unmarried couples could stroll unchaperoned, a sort of semiofficial lovers' lane." The site of the 19th-century lovers' lane is now an unadorned footpath east of the mall, just south of the Naumburg Bandshell.

The Mall and Environs: Marble Arch to Terrace Bridge

Designed by Jacob Wrey Mould and built in 1862, the music pavilion stood at the northwestern edge of the mall. As described in the *100th Anniversary Celebration of the Naumburg Orchestral Concerts*, "Mould pulled out all the stops for this design. The raised platform was covered by a Moorish-style cupola, dark blue and covered with gilt stars . . . topped by a sculpture of a lyre. The roof [was] supported by crimson cast-iron columns." Ultimately the music pavilion fell into disrepair and was demolished in 1923. Today a flagpole stands on the site.

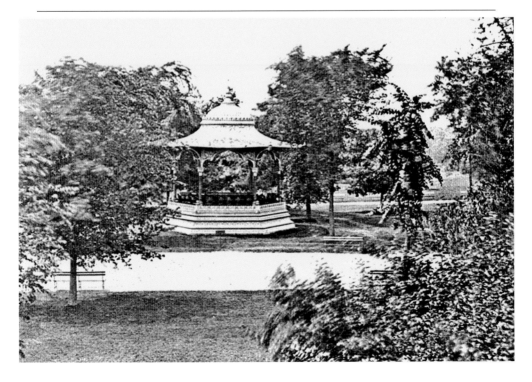

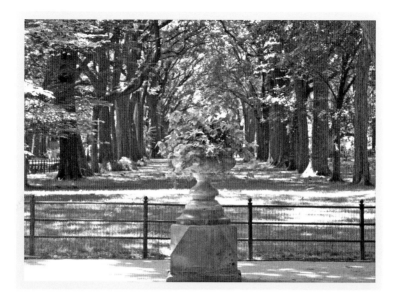

The early photograph shows two spiffily dressed young visitors at the northern end of the mall as they partake of ice water from one of the park's early drinking fountains. Built of granite with bronze fixtures, the fountains, according to Sara Cedar Miller's *Central Park, An American Masterpiece*, provided water that was "pumped over blocks of ice that were taken from the Park's water bodies in the winter, stored, and placed below the drinking fountain in deep pits." In the contemporary image, a well-maintained planter has replaced the fountain.

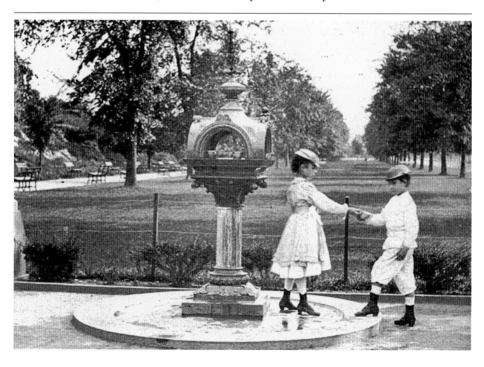

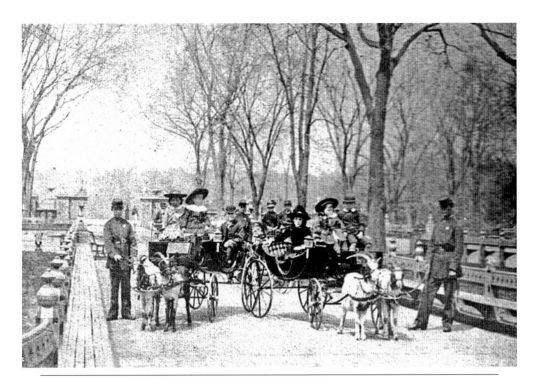

When the park opened, goats running wild on the grounds presented a problem. Soon, however, entrepreneurs came up with the creative solution of goat carts. A ride, costing 10¢, was anything but affordable. Four-time New York State governor Alfred E. Smith (1873–1944) wrote in his 1929 autobiography, *Up to Now*, "A trip to Central Park, with a ride in the goat wagon, was something that came to you on your birthday, if you were lucky." On today's mall, goat carts and pony rides have been replaced by strollers.

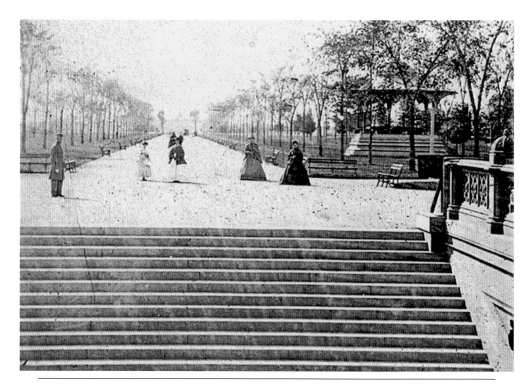

Pictured here in a southward view from Terrace Bridge is the broad flight of steps that lead from the arcade beneath Terrace Bridge to the mall. In the early photograph, the music pavilion is seen at right, while proper Victorian ladies under the watchful eye of a patrolman (at left) enjoy a stroll among the recently planted elms. In the contemporary image, the elms have filled out considerably and a vendor sells refreshment to a less formally clad cadre of park visitors.

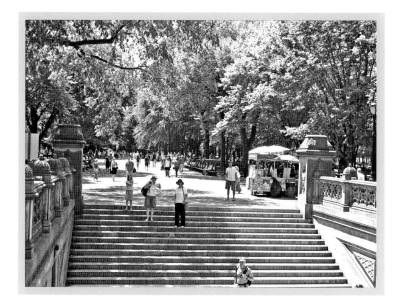

The Heart of the Park

Bethesda Terrace to

Croton Reservoir

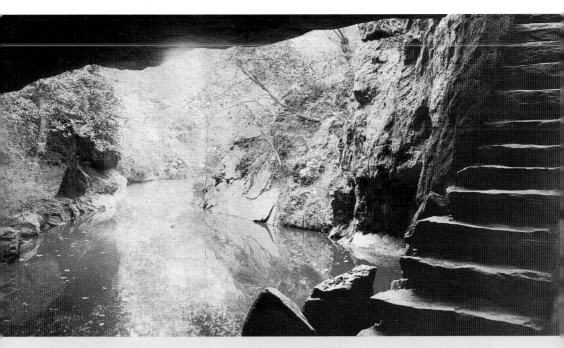

As described in *New York Focus*, the cave, in an inlet at the northeastern edge of the lake, was "created as a port of adventure for rowers who could leave their boats to explore the area . . . it added an unusual mystique to the Park experience. When it became too dangerous to maintain, it was sealed and the inlet was filled." A precipitous flight of stone steps, leading down from the Ramble to the cave, is the only present reminder of its former existence.

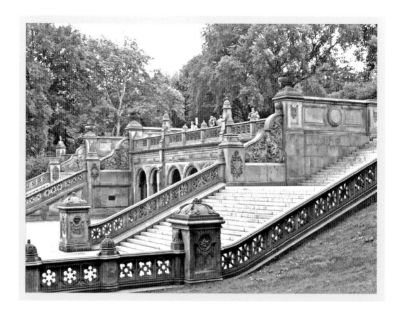

Among Central Park's architectural elements, perhaps the best known and most loved are two staircases of New Brunswick sandstone. The grand stairs descend from Terrace Bridge to Bethesda Terrace's seven-arch arcade, its broad esplanade, and the Angel of the Waters fountain. Described by Frederick Law Olmsted and Calvert Vaux as "the climax" of the Greensward Plan, Bethesda Terrace features elaborate and exquisite ornamentation by Jacob Wrey Mould. Thanks to faithful restorations by the Central Park Conservancy, Bethesda Terrace has remained remarkably unchanged during its 150-year existence.

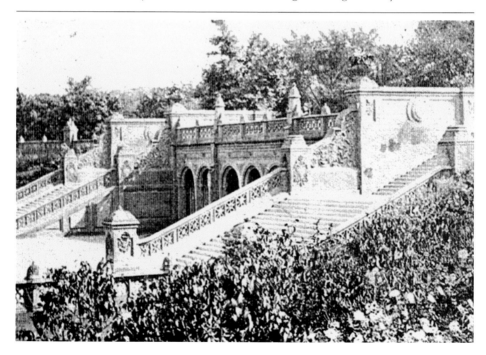

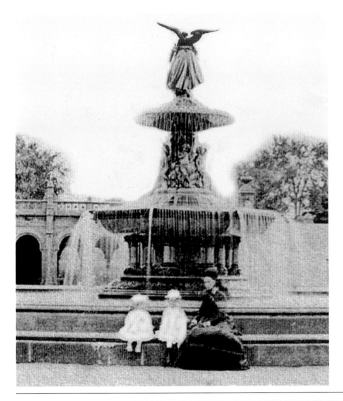

"The Playground of the Metropolis," an article by Arthur Wakeley in the September 1895 *Munsey* magazine, describes the Angel of the Waters fountain, "In the center of the Esplanade, and at the foot of the Terrace, is one of the show ornaments of the park. [Angel of the Waters] stands high over the edges of the upper basin . . . the murmur of the fountain is sustained and low, and the ripples of the lake lap the shore gently." More than 100 years hence, Wakeley's description captures the appeal of what is perhaps New York's greatest fountain.

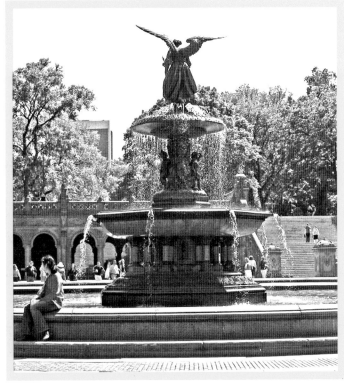

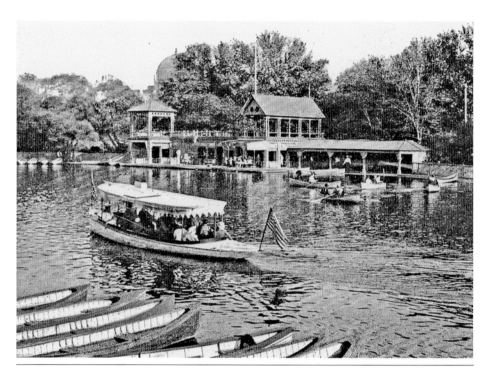

Just north of Bethesda Terrace is the lake, which has long been famous for boating. In the early days of the park, rowboats, gondolas, and picturesque contraptions known as swan boats were available for rental. Calvert Vaux's original 1870s Victorian boathouse, pictured in the historical image, stood just east of the terrace on the lake's southern shore. After it was destroyed in a fire, the current Loeb Boathouse was built in a cove at the lake's eastern edge. Today it is home to the boat rental operation; a snack bar; and the Boathouse Restaurant, known for fine dining.

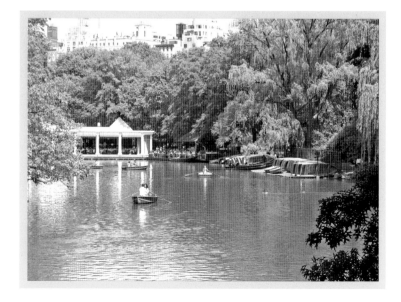

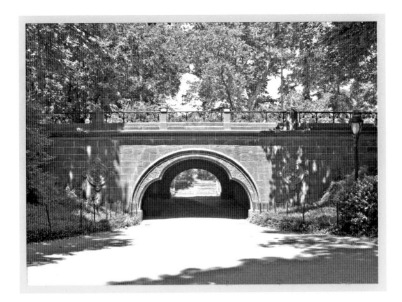

Due east of the boathouse is the 1862 Gothic-style Trefoil Arch, designed by Vaux and Jacob Wrey Mould. The arch's distinctive eastern facade, featuring a three-lobed, or trefoil, pattern carved in brownstone, is responsible for its name. Carrying the East Drive over its 110-foot passageway, Trefoil Arch leads to Conservatory Water, and to two of the park's best-known statues, Hans Christian Andersen and Alice in Wonderland. The historical and contemporary views of Trefoil Arch are strikingly similar, marked only by the growth of surrounding vegetation.

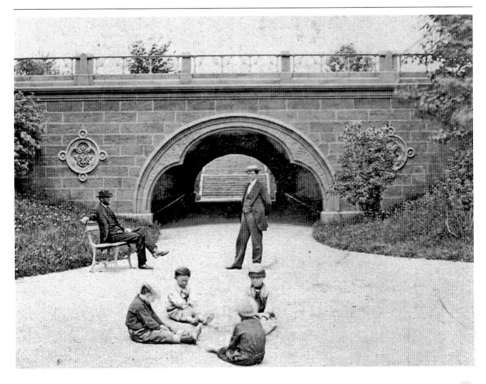

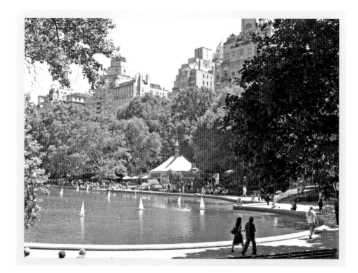

The sight of model yachts sailing on the Conservatory Water is one that dates from the park's very earliest days. Also known as the Model Boat Pond, the oval-shaped body of water at the park's eastern edge near 74th Street was named for the conservatory, which was planned but never built. The dome of the spectacularly appointed, Romanesque-style Temple Beth El is visible on Fifth Avenue in the historical photograph; in 1947, the temple was demolished and replaced by an apartment building, which can be seen in the contemporary image.

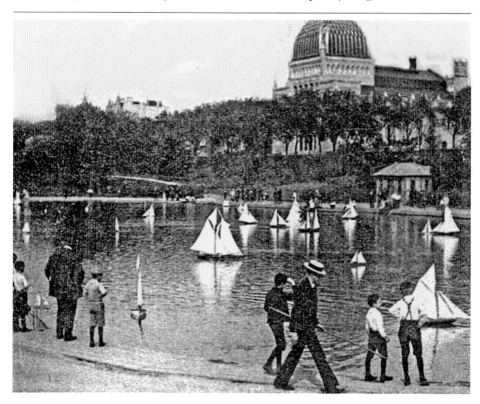

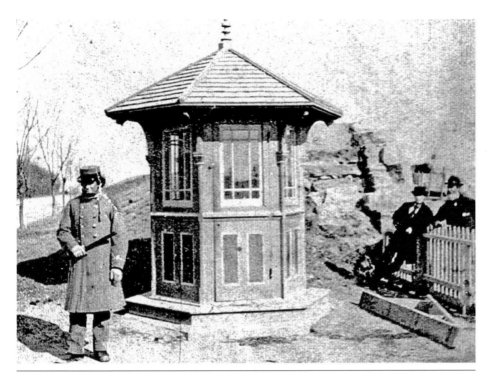

When the park first opened, each gate had a gatehouse and a gatekeeper, who earned 90¢ per day. Frederick Law Olmsted wrote in 1860, "[They] are at present required to be at their posts from 11 to 12 hours together every day, including Sundays. This is more than it is right under ordinary circumstances to demand of any men." Twelve additional gatekeepers were hired soon thereafter. In the modern image, a historically accurate reproduction of an original kiosk houses a Central Park Conservancy volunteer, who provides information to the public.

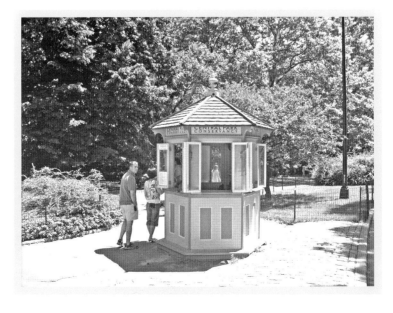

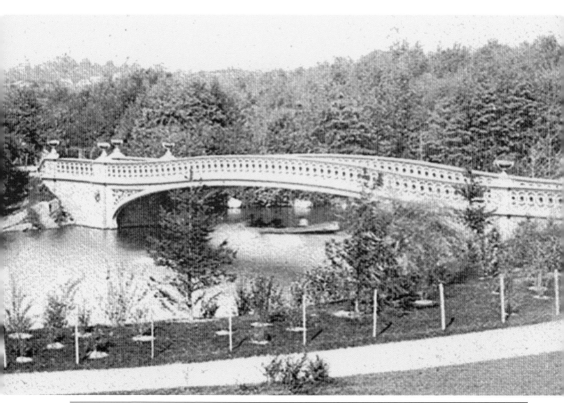

Bow Bridge, designed by Calvert Vaux and Jacob Wrey Mould, was constructed in 1859 and 1860 by Janes, Kirtland, and Company, the builders of the Capitol dome in Washington, D.C. In their 2006 book, *The Bridges of Central Park*, Jennifer C. Spiegler and Paul M. Gaykowski wrote of Bow Bridge, "This graceful wrought iron bridge . . . elegantly crosses the lake, allowing foot traffic to flow over blissful boaters and sassy swans. Its name derives from its resemblance to the graceful lines of an archer's bow."

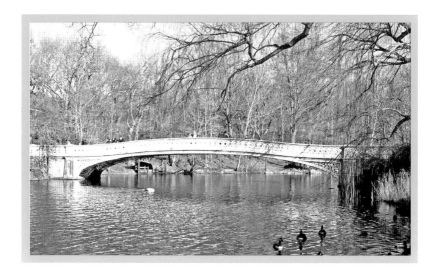

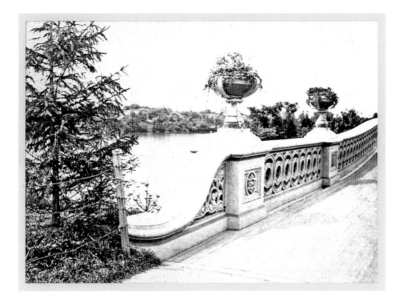

Bow Bridge's 142-foot span connects Cherry Hill and Bethesda Terrace at its southern end with the Ramble to the north. Of all the bridges in the park, Bow Bridge is the best known and most photographed. Its original cast-iron structure included eight vases, with four at each end. As evidenced in the 19th-century photograph, plantings were attractive and well maintained. However, the vases were removed during a restoration, and there are no current plans to replace them.

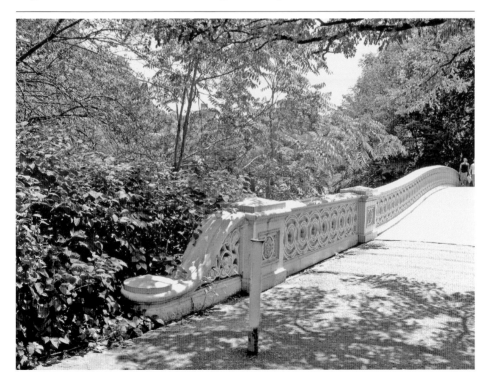

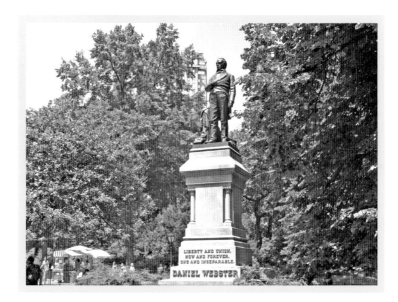

Just east of the West Drive near 72nd Street stands Thomas Ball's 1872 bronze statue of the statesman Daniel Webster. Originally intended to stand at the mall, the statue was too large for its planned space and was instead installed in its present location.

In the historical photograph, the original Majestic Hotel may be seen to the left of the statue and the Dakota is visible at right. In the contemporary view, the 1931 Majestic Apartments peek out from between the trees beside Daniel Webster's elbow.

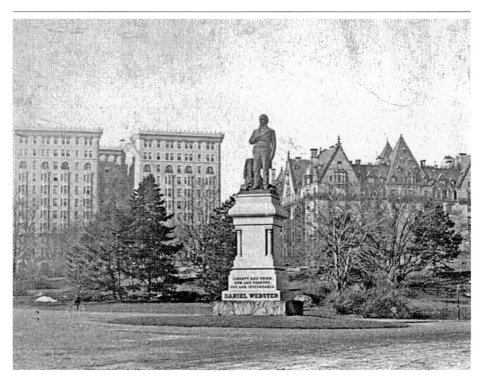

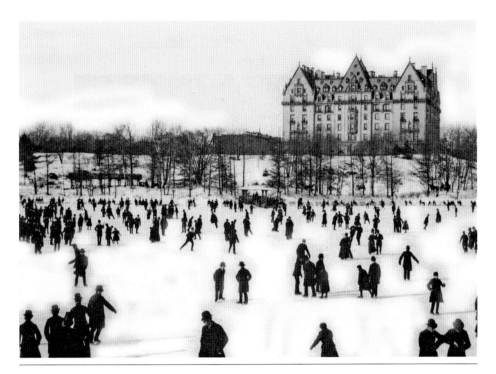

The iconic photograph, titled "Skating in Central Park, Near the Dakota Apartment House," taken in the 1880s by an unidentified photographer, originally appeared in the 1893 edition of *King's Handbook of New York City*. The lake was one of the more popular early venues for ice-skating in winter. In the contemporary image, foliage has grown; however, the Dakota is still there, flanked by the Majestic Apartments to the south and the Langham to the north. Since 1950, skating has been prohibited on park waterways, and today the ice is rarely thick enough to support it.

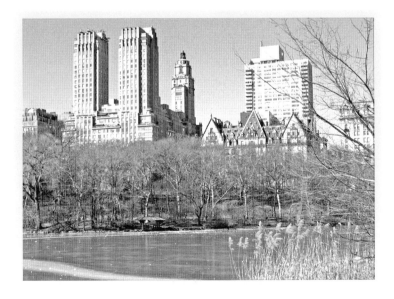

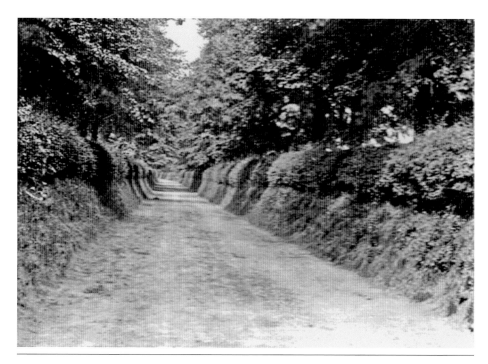

In 1895, Arthur Wakeley wrote in praise of the bridle paths in *Munsey* magazine, "The architects have given special attention to these paths, and some of the most picturesque views of the park are to be obtained only from the saddle." Originally there were six miles of bridle path, much of it lined with ornamental hedgerows, as seen in the 19th-century image. Today only 4.2 miles remain, as the lower branch of the bridle path ends near Heckscher Playground rather than looping around to Scholar's Gate at 60th Street. Both the historical and contemporary images were taken near 77th Street.

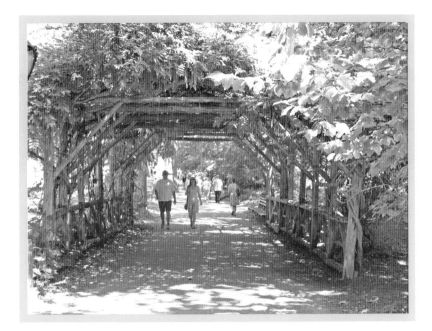

In the same *Munsey* magazine article cited on the previous page, Wakeley also wrote, "In thirty miles of walks about the park . . . there is no end to the shady arbors . . . every path leads you sooner or later to some such place." The historical photograph pictures a rustic arbor along West Drive near 72nd Street; the contemporary image of the same location illustrates how little some park features have changed in the intervening 110 or so years.

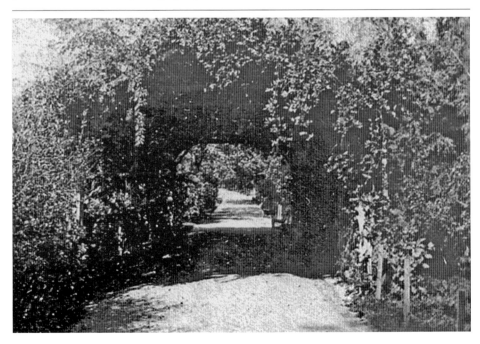

The Calvert Vaux–designed Balcony Bridge, carrying what was then known as the Winter Drive (now the West Drive) near 75th Street, connected an arm of the lake nearest to Central Park West to a now-defunct body of water known as Ladies' Pond. Once reserved for female ice-skaters, Ladies' Pond was filled in during the 1930s, and the once-vibrant body of water that ran beneath Balcony Bridge's 27-foot-wide, 12-foot-high arch has been reduced to a trickle. At this writing, restorations of Balcony Bridge and Ladies' Pond have been proposed and are in the early stages of planning.

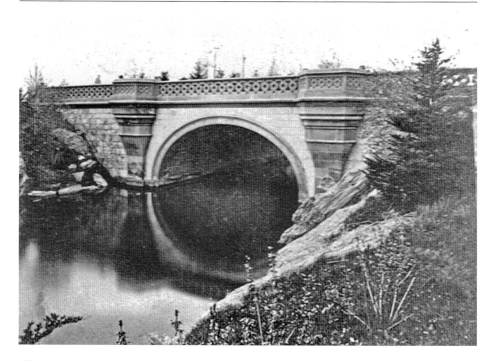

The 1860 vintage Bank Rock Bridge, also known as Oak Bridge, was a footbridge crossing Bank Rock Bay west of the Ramble at about 77th Street. Standing approximately 50 yards north of Balcony Bridge, it was built predominantly of white oak with yellow pine decking and cast-iron accoutrements. As part of the ongoing restoration of the lake, Bank Rock Bay and the bridge area are closed at this writing; when they reopen, a new Bank Rock Bridge, built to the specifications of the original structure, will be in place.

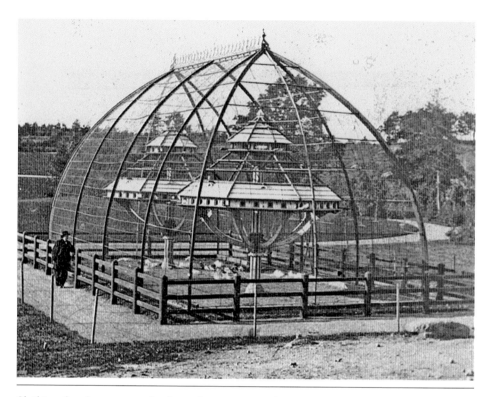

Shifting for the moment back to the east side, the historical photograph shows a structure known as the dovecote, or pigeon house. It stood just inside the park, near Fifth Avenue and 78th Street. Consisting of a cast-iron frame with two conical cages inside, it appears on the earliest park maps; however, no record has been found of when it was removed. The dovecote's former location is now occupied by the James Michael Levin Playground.

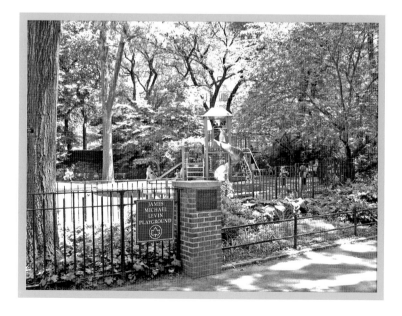

This historical photograph illustrates Transverse Road No. 3 from a western perspective. On the right side of the image is the northern edge of the Ramble, and the on left side of the image stands the original Croton, or Lower, Reservoir. The road, which was altered slightly so that it now connects East 79th Street with West 81st Street, is seen in the contemporary view from a vantage point high above the roadway, on the former Tower Hill, now known as Vista Rock. (Contemporary photograph courtesy of Edward J. Levine.)

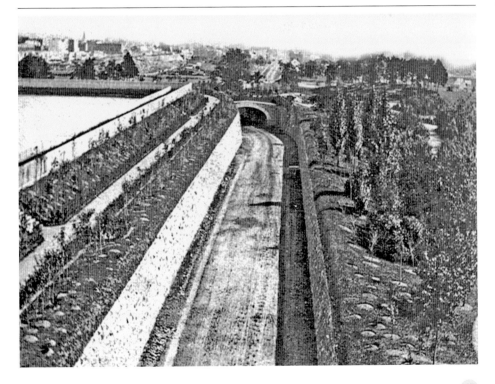

Frederick Law Olmsted and Calvert Vaux's idea of placing the park's transverse roads below grade level, which enabled park visitors to avoid clashes with crosstown traffic, was among Central Park's cleverest design elements. The historical photograph shows Transverse Road No. 3 heading west at 79th Street under what was then called Tower Hill. While the park was being built, foremen rang the bell in the tower several times each day to signal the park's construction crews for the start and end of their shifts.

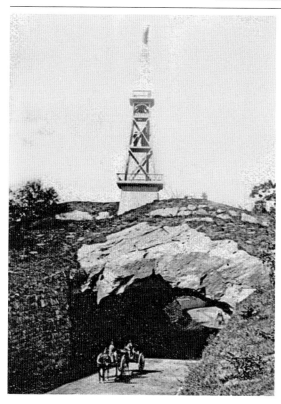

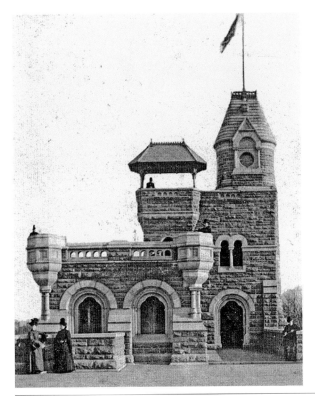

The 1870 Gothic-style Belvedere Castle, designed by Calvert Vaux and Jacob Wrey Mould, stands on Vista Rock just north of the Ramble. The castle's observation deck provides the highest elevation and the best aerial perspective in the park. Since the early 20th century, the U.S. Meteorological Society, now the U.S. Weather Bureau, has taken New York City's temperature and other readings from a station at the castle. Aside from the foliage grown up around it, Belvedere Castle appears to have changed very little during its 140-year existence; however, its current pristine condition is due to the restoration efforts of the Central Park Conservancy.

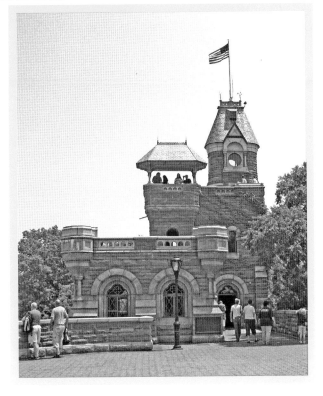

Just north of Belvedere Castle, along the western edge of the Lower Reservoir, stood a narrow, tree-lined corridor known as Berceau Walk. Modeled after several similar walks found in Europe (one in Normandy is almost a mile long), Berceau Walk featured a rustic pergola at its southern end. Berceau Walk's popularity as a destination among courting couples led to its nickname, "Flirtation Walk." Today a path is located in the same place and is popular with people walking their dogs.

THE HEART OF THE PARK: BETHESDA TERRACE TO CROTON RESERVOIR

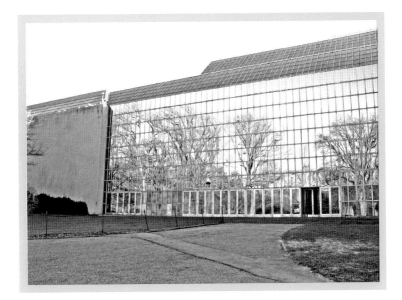

The earliest incarnation of the Metropolitan Museum of Art in 1880 was a modest brick building designed by Calvert Vaux and Jacob Wrey Mould, located just inside the park near East 82nd Street. During the intervening years, the museum has undergone significant changes. As illustrated in the modern image, the original entrance and driveway design, which was subsumed by the expanded building, has been recast as a mirrored structure facing the East Drive near the great lawn.

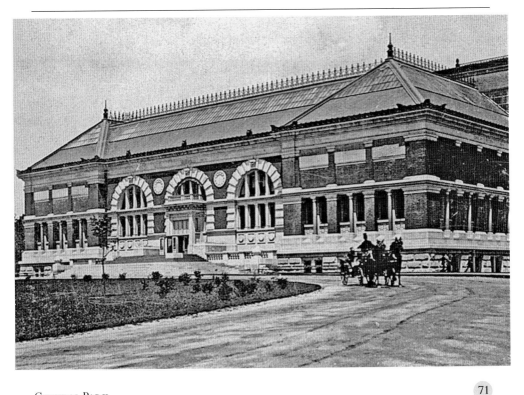

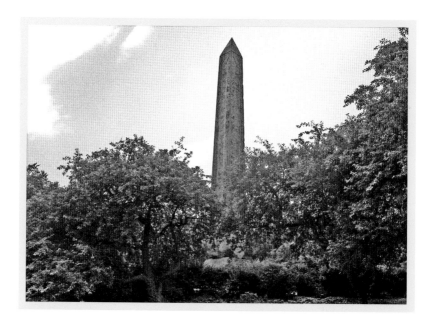

The obelisk, at 3,500 years old, is commonly but mistakenly referred to as Cleopatra's Needle. It is actually a tribute to Egyptian Pharaoh Thutmosis III, and is the oldest man-made structure in Central Park. The 71-foot, 244-ton granite needle, which has stood on a hillside just north of Greywacke Arch since 1881, originated in Heliopolis and was moved to Alexandria before its oceanic journey to its current home.

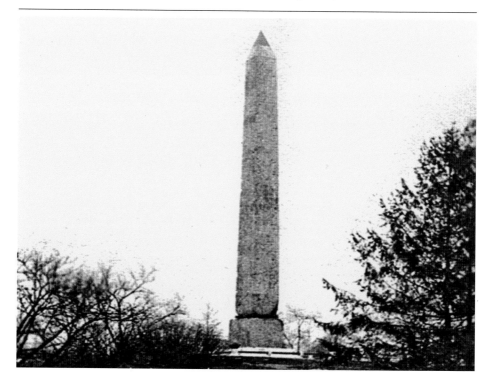

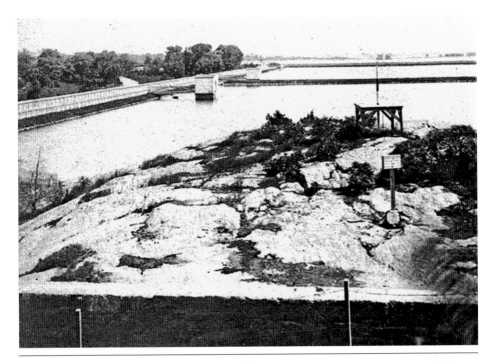

The 1840 Lower Reservoir covered 136 acres midpark between 79th and 86th Streets. It became obsolete once the new Croton Reservoir was opened. *The Park and the People* states that a debate ensued over what to do with the land once occupied by the old structure. Among the ideas that were floated and rejected were to roof it over and create an exhibition palace or to build a bridge to connect the American Museum of Natural History and the Metropolitan Museum of Art. The old reservoir was drained in 1931, and today Turtle Pond and the great lawn occupy the site.

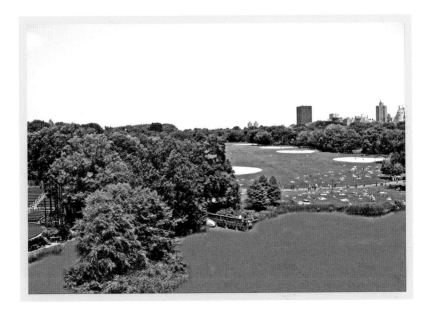

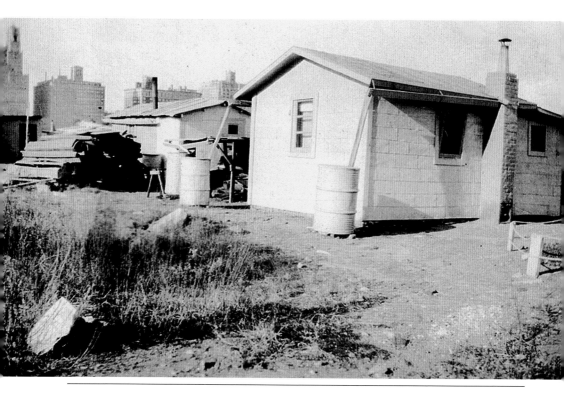

Between the time of the old reservoir's draining and the development of the great lawn, homeless men lacking jobs built ramshackle huts and took up residence on the site. The vintage photograph was taken by a German tourist on Christmas Day in 1933. By mid-decade, pressure was brought to remove the shantytown known as "Hooverville," and the 13-acre great lawn was finally completed in 1937. Today ball fields, added in the 1950s, are the dominant feature of the splendid expanse of lawn.

THE HEART OF THE PARK: BETHESDA TERRACE TO CROTON RESERVOIR

Constructed between 1858 and 1862, the "new" Croton Reservoir occupies most of the park between 86th and 96th Streets. For many years, it was one of the major sources of New York City's drinking water. In 1994, it was officially renamed the Jacqueline Kennedy Onassis Reservoir for the former first lady who ran daily on the path that surrounds it. The reservoir's steel-and-cast-iron perimeter fence was restored by the Central Park Conservancy in 2003, and in 2007, the 1917-era fountain, seen in the contemporary photograph, was activated for the fourth time in history to commemorate the anniversary of New York's water system.

The September 1895 issue of *Munsey* magazine waxed poetic about the park's bridle trails, "Early in the morning, in spring or autumn, these byways are alive with equestrians . . . A party from a riding school charges down upon you like a troop of cavalry and disappears around a turn, into the woods." A group of riders, dressed to the nines, is seen in the historical photograph; a lone rider makes her way north around the reservoir in the modern image.

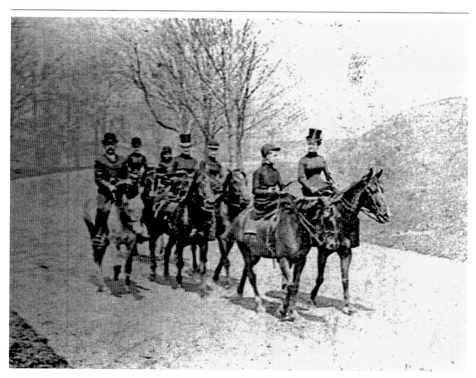

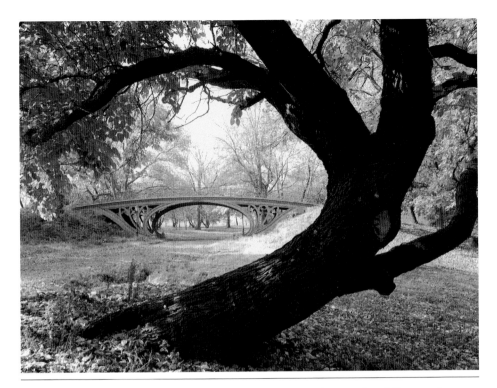

Just north of the reservoir stands one of the parks original cast-iron bridges, known today as Gothic Bridge. Designed by Calvert Vaux, Gothic Bridge spans the bridle path between the reservoir and the tennis facility. The bridge is slightly over 15 feet tall and features an arch 37 feet in width. Gothic Bridge fell into disrepair over the years, but unlike the doomed Spur Rock and Outset Arches, it was saved. Restoration to its original glory was completed by the parks department in 1983.

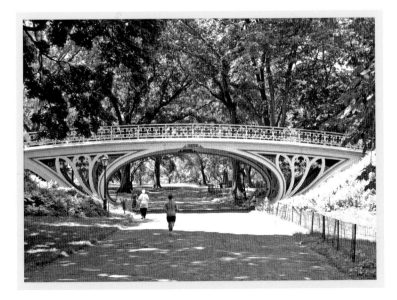

First played during the tennis craze of the 1880s on temporary courts that were laid out throughout the park, tennis has been a staple in Central Park ever since. Asphalt courts, built during the early 20th century, have been replaced by clay. Today the tennis center occupies a site just off the West Drive near 96th Street. In the contemporary photograph, an apartment building on Central Park West is visible in the background.

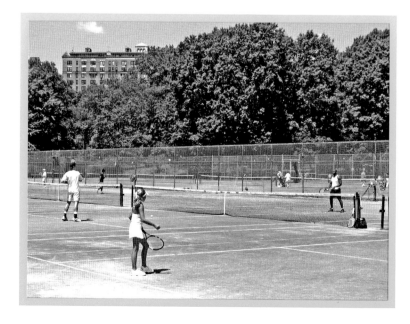

THE HEART OF THE PARK: BETHESDA TERRACE TO CROTON RESERVOIR

THE NORTHERN END

NORTH MEADOW TO

HARLEM MEER

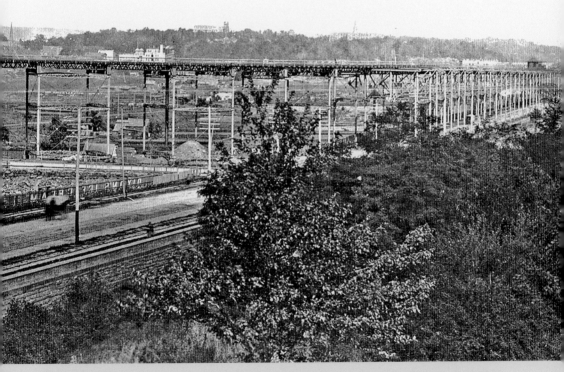

In 19th-century New York, elevated trains operated high above many avenues. Among them was the Ninth Avenue line, which ran from South Ferry to 110th Street, where it made two sharp turns in rapid succession as it chugged its way toward its 155th Street terminal. The first was a 90-degree right turn onto 110th Street, and the second (illustrated here) was a 90-degree left onto Eighth Avenue. This double curve took place more than 100 feet above street level, earning it the popular nickname of "Suicide Curve." The Ninth Avenue el ceased operation in 1940.

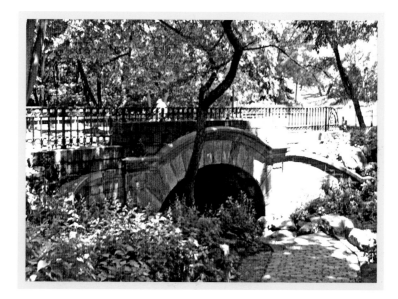

The 1863 stone-and-masonry Springbanks Arch was designed by Calvert Vaux and Jacob Wrey Mould. It runs beneath the bridle path at the northern tip of the North Meadow. According to Henry Hope Reed, Robert M. McGee, and Esther Mipaas in *Bridges of Central Park*, Springbanks Arch bears "a striking resemblance to some of the archway facades at Regent's Park in London. The concrete walk beneath the arch was originally one-half its present width. A stream fed by a spring that drains the North Meadow south of the arch flowed underneath as well." Today the stream still exists, but it is confined to a pipe that runs beneath the walkway.

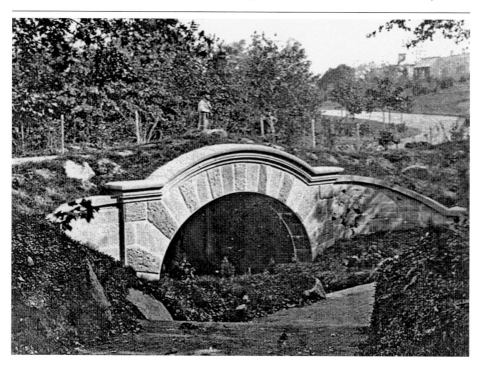

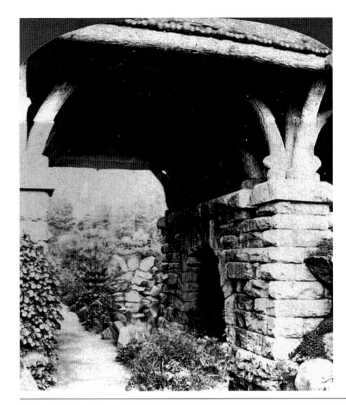

Glen Span Arch, originally known as Grotto Bridge when it was designed by Vaux and Mould, dates from 1865. When first completed, it featured a wooden roadway, which was replaced by rustic stone in 1885. Glen Span Arch is known for two distinctive features. One is a stream, which runs underneath the archway and leads to the densely wooded ravine in the northern end of the park; the other is its decorative grotto that is characteristic of the British Picturesque style in which it was designed.

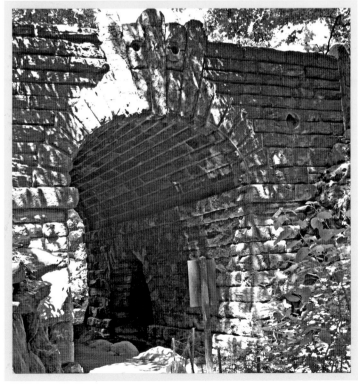

At the western end of Glen Span Arch's passageway lies the pool, which underwent a major restoration by the Central Park Conservancy in 2003. The pool area features a rural vista that typifies the wilderness of the park's northern environs as originally envisioned by Frederick Law Olmsted and Calvert Vaux. Fed by a pipe that is connected to the reservoir, the pool's water is the source of several waterfalls, the loch, and Harlem Meer to the north. Buildings along Central Park West are visible in both historical and contemporary photographs.

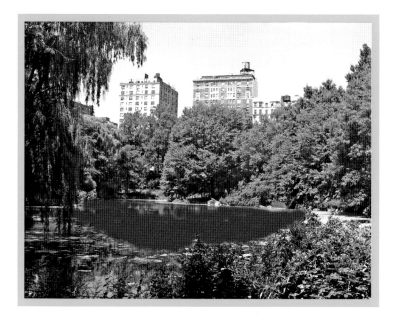

Northeast of the pool and Glen Span Arch lies what is perhaps the park's wildest area, the ravine, which is the park's only stream valley. A vital element of the park's 90-acre North Woods, the ravine features five man-made waterfalls and follows the path of a stream that is better known as the loch. Before the ravine became clogged with silt, the amount of water flowing along the ravine was greater than it is today. Other than the water flow, historical and contemporary images, both taken just south of Huddlestone Arch, are surprisingly similar.

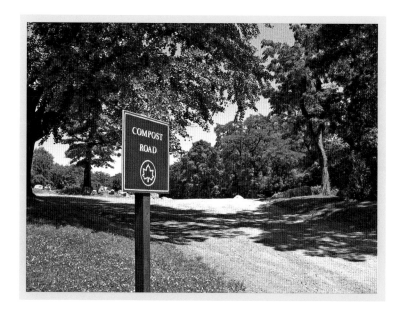

The northeastern corner of Central Park once featured several buildings that are no longer in existence. One of these, McGown's Tavern, was built in 1883 and stood until Mayor John Purroy Mitchel had it torn down in 1917. As noted by Henry Hope Reed and Sophia Duckworth in *Central Park, a History and a Guide*, "Reforming mayors seem to have an antipathy for park restaurants, *vide* Mayor LaGuardia and the destruction of the old Casino." The McGown's site is now a road that leads to the park's composting operation.

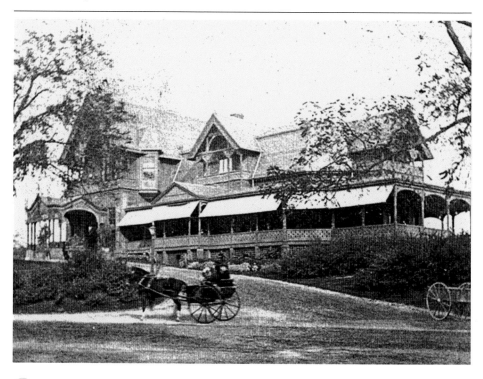

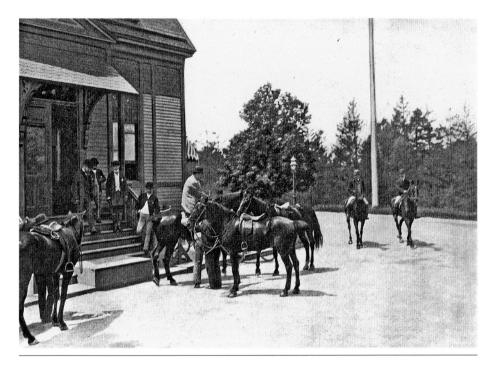

An early view of McGown's Tavern is more reminiscent of the old west than of Manhattan. The McGown family, which operated the tavern as far back as the 18th century, is remembered by McGown's Pass, the site nearby where the East Drive drops and turns toward the west. Today a piece of the foundation of their early tavern remains visible atop the hill, which rises above the western edge of the Conservatory Garden. (Historic photograph courtesy of Bob Stonehill.)

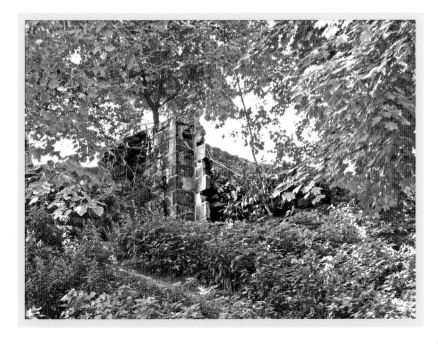

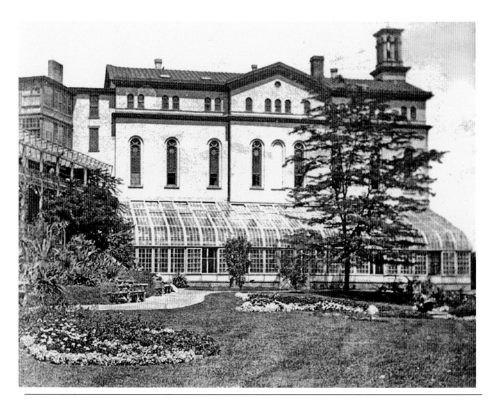

The first McGown's Tavern was taken over by the Sisters of Charity of St. Vincent de Paul in 1845. They established the academy and convent of St. Vincent and erected a new arts building, which is seen in the historical image. During the Civil War, the building was used as a soldiers' hospital. It was destroyed in a fire in 1881, and its foundation, which can be seen in the modern photograph, is all that remains of the Mount St. Vincent complex.

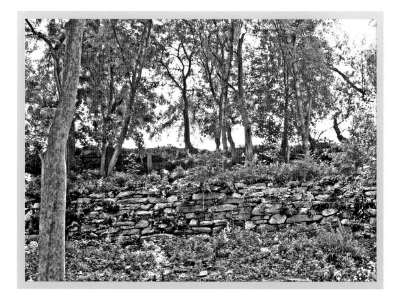

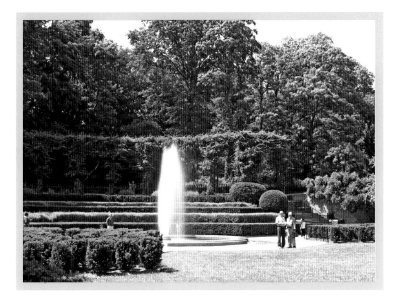

The last of four McGown's-Mount St. Vincent images shows the original fountain near the greenhouses, which once stood where the Conservatory Garden is today. A tall flight of stairs, long since demolished, led up the hill from the greenhouse area to the Mount St. Vincent complex. The fountain shown in the contemporary image is of 1930s vintage, and a lush semicircular pergola at the western edge of the Conservatory Garden has replaced the stairway.

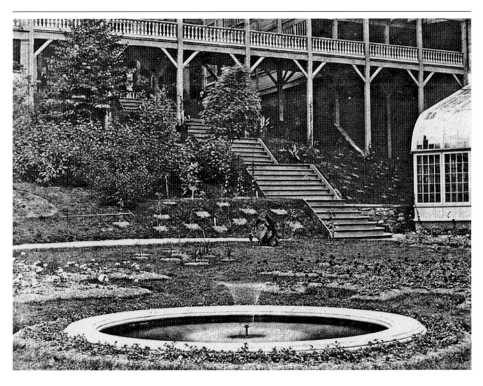

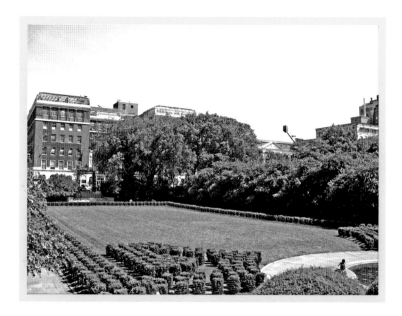

Frederick Law Olmsted and Calvert Vaux's early plan for Central Park included an arboretum in the northeast corner, which was never built. Instead a large greenhouse, the northern edge of which is visible in the historical image, was erected just inside the park near Fifth Avenue and 105th Street. The greenhouse stood until 1934 and was replaced several years later by the current Conservatory Garden, which features French, Italian (pictured in the contemporary image), and English gardens.

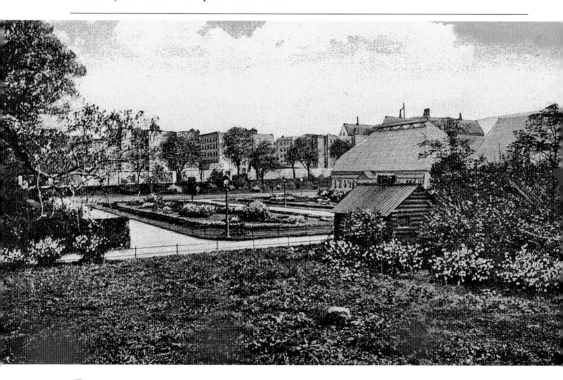

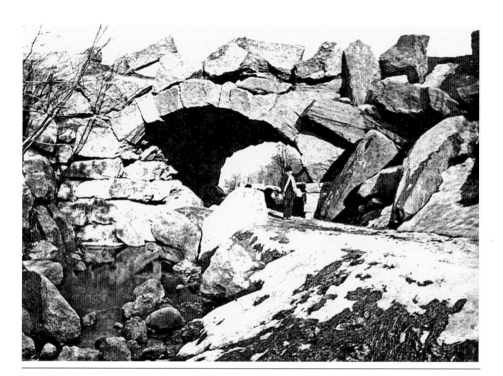

In the vicinity of 106th Street about midpark stands the picturesque Huddlestone Arch. Designed by Calvert Vaux and built in 1866 entirely of boulders harvested during the park's construction, the 22-foot-wide arch carries the West Drive over a brook and pathway. It connects the ravine to the south with Lasker Rink and Harlem Meer to its north. As described by Henry Hope Reed, Robert M. McGee, and Esther Mipaas, "In season, one of the attractions of Huddlestone is the lacelike vines that spill over the cyclopean rock on the bridge's south side." The vines are visible in the modern image.

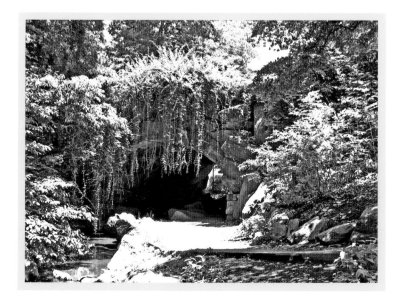

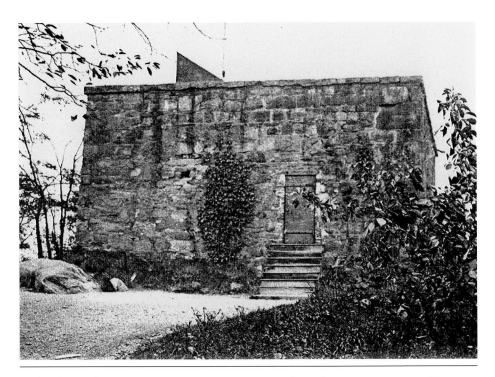

High above the West Drive resting on a rugged outcrop is the park's oldest building, the blockhouse. One of several forts built in the area to defend New York against the British during the War of 1812, the blockhouse was decommissioned when the war ended in 1814. For many years, it was an abandoned ruin, providing no sign of its former importance. However, the building has recently been stabilized and now features a parks department sign describing its historical significance. Today the surrounding foliage has obscured the blockhouse's once-panoramic view of upper Manhattan, as well as the blockhouse itself.

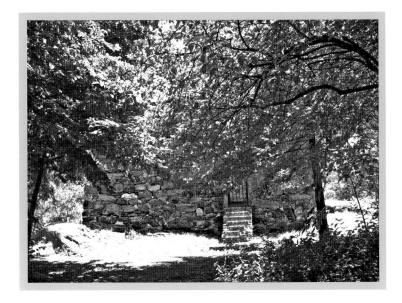

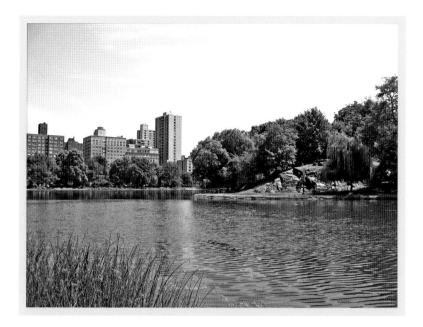

Harlem Meer (*meer* is Dutch for lake) is an 11-acre, man-made body of water in the park's northeastern corner. As described by the Central Park Conservancy, whose 1993 restoration is responsible for the meer's splendid condition, "The Meer and the wooded landscape that surround it . . . are a thriving habitat for wildlife, home to several fish and turtle species, [as well as] year-round and seasonal migrant species of waterfowl." Except for the tall buildings overlooking the water in the contemporary image, it has changed very little over the years.

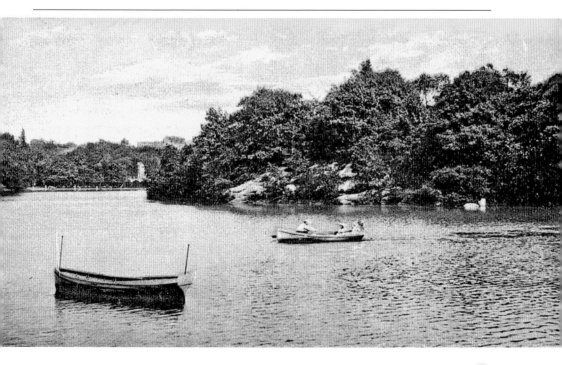

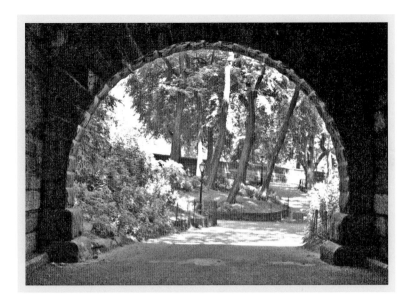

The massive Mountcliff Arch, among the largest bridges in the park at 102 feet long and 48 feet high, features a Tuscan-style arch, which measures 16 feet high and 21 feet wide. It was built in 1890 and carries automobile traffic to the West Drive from the park's entrance at 110th Street and Central Park West. The apartment house on 110th Street, which is visible in the historical photograph, is still standing. However, it is now obscured by lush foliage during the summer months, which is when the modern photograph was taken.

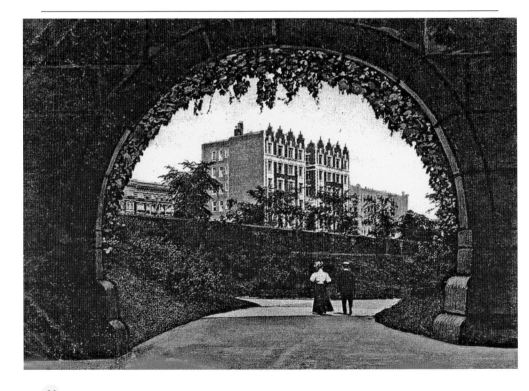

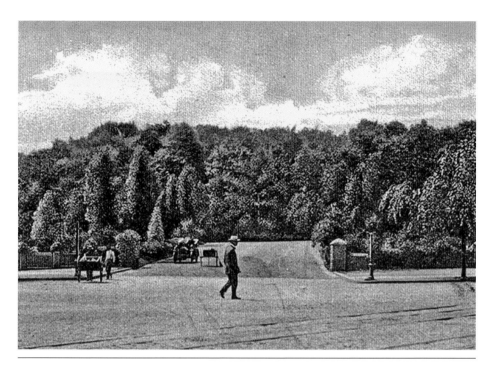

A comparison between the historical and current views of Stranger's Gate at 110th Street and Central Park West reveals that the more things change, the more they remain the same. A lone pedestrian strolls toward the west in each image; however, the gentleman of yore was alone with his thoughts, while the modern woman is chatting on her cell phone. The historical photograph also features a vendor's pushcart and a vintage automobile, while the modern photograph shows a maintenance worker's electric cart. Only the streetcar tracks are missing in the contemporary image.

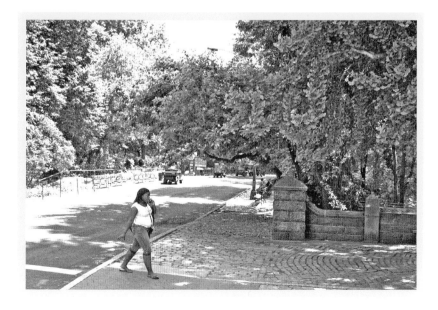

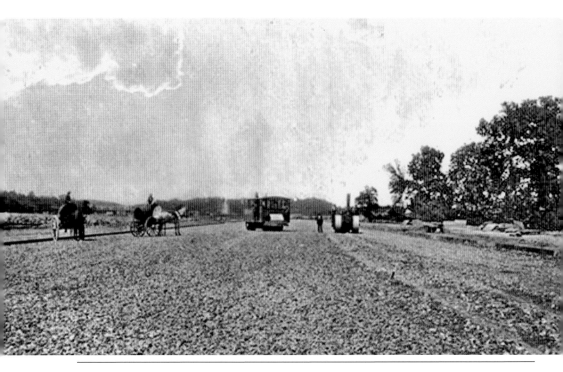

Two northerly views, taken from the vantage point of Farmer's Gate at Sixth (now Lenox) Avenue and 110th Street, demonstrate how the city has grown during the more than 100 years separating the two images. The historical image, taken during the 1890s by American photographer George Rockwood, reveals a meager landscape, a few trees, two wagons hitched to horses, and what appear to be construction workers grading Sixth Avenue. Little over a century later, Lenox Avenue is a mature thoroughfare, featuring all the familiar signs of modern urban life.

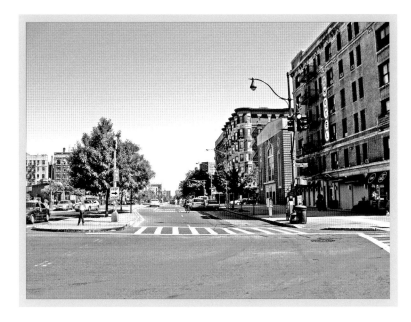

Bibliography

Harper's Monthly. September 1879.

Karp, Walter. "The Central Park." *American Heritage.* April/May, 1981.

Miller, Sara Cedar. *Central Park, An American Masterpiece.* New York: Harry N. Abrams, 2003.

Reed, Henry Hope, and Sophia Duckworth. *Central Park, a History and a Guide.* New York: Clarkson N. Potter and Company, 1967.

Reed, Henry Hope, Robert M. McGee, and Esther Mipaas. *Bridges of Central Park.* New York: Greensward Foundation, 1990.

Rosenzweig, Roy, and Elizabeth Blackmar. *The Park and the People.* New York: Henry Holt and Company, 1992.

Scribner's. October 1873.

Spiegler, Jennifer and Paul M. Gaykowski. *The Bridges of Central Park.* Charleston, S.C.: Arcadia Publishing, 2006.

State of New York, Senate Report Number 18. *Report of Special Committee appointed to examine into Condition, Affairs and Progress of the New York Central Park.* January 25, 1861.

Wakeley, Arthur. "The Playground of the Metropolis." *Munsey,* September, 1895.

www.centralpark2000.com

www.centralparknyc.org

www.greenswardparks.org

www.naumburgconcerts.org/mall-a.htm

www.arcadiapublishing.com

Discover books about the town where you grew up, the cities where your friends and families live, the town where your parents met, or even that retirement spot you've been dreaming about. Our Web site provides history lovers with exclusive deals, advanced notification about new titles, e-mail alerts of author events, and much more.

Find Your Place in History.